# MADE IN

## THE MUSIC OF AT

# JANETTE

FOREWORD BY PAUL SMITH   ESSAYS BY VIVIEN GOLDMAN AND PAOLO HEWITT

This book is dedicated to all the rebel rockers past present and future.

# THE UK
# ITTUDE 1977–1983
# BECKMAN

pH powerHouse Books   NEW YORK, NY

Since the late fifties certain trends in fashion have had strong links with music. Interestingly, the various styles or "looks" were often not created by designers, but by groups of people, frequently from working class families, who wanted to express themselves and form their own identity.

Mods, starting out as far back as the early sixties, took inspiration from American G.I.s (still in London from the war) who wore lightweight, mohair suits made-to-measure with button-down collar shirts. But above all, the most important thing is that they were really considering how they looked—hair, socks, shoes, everything. Never had youth been so self-conscious.

The punk movement was rebellious, antiestablishment, and intended to shock. The designers Malcolm McClaren and Vivienne Westwood dominated the punk fashion scene through their famous shop on King's Road in London. The Sex Pistols (created and managed by McClaren) inspired a whole wave of punk bands.

Janette's book documents the era in an interesting and exciting way; the rebellious punks, stylish mods, aggressive skinheads, monochrome 2-Tones, and Edwardian rockabillies.

The photograph of Paul Weller and Pete Townshend completely sums up my teenage years—self-conscious and fanatical about detail. The book also shows how the music industry has changed. Back then, it was basic, down-to-earth photographs, taken in scruffy clubs or backstage changing rooms. Today everything is so "thought about," image-conscious, marketed, and packaged. I know which I prefer.

Paul Smith

You know the way time seems to stretch forever when you're a kid at school? Like how summer vacation seemed to last as long as a year does when you're thirty. Well, just before the dawn of the punk era there really was a darkest, dreariest hour. T-E-D-I-U-M ruled in the editorial meetings of the feisty little underdog rock weekly, *Sounds*, where I was Features Editor in the mid-seventies, sending photographers like Janette Beckman out to cover stories. The Big Names we were supposed to salivate about, and scrap over with our rivals *Melody Maker* and *New Musical Express*, formed the same old roll call—Stones, Floyd, etc.—that had been around since the prehistoric sixties.

The jolt of punk was desperately needed in complacent old England, still wallowing in the afterglow of having run our many colonies across the globe. There was a terrifying sameness about a Britain where everything closed at 5:30 P.M. and all day on Sundays. Not to mention the three-day workweek, leaving folks more broke and with more time for doing good and/or bad. The country was sliding deeper into unemployment and after seemingly interminable years in power, the Labour government appeared to have only succeeded in deepening the social inequities it had planned to prevent. The specter of the Queen's Silver Jubilee in 1977 seemed to symbolize everything that was stultifying about the British establishment. It was definitely time for a new order, and JB was there to adore it all with her camera.

The first gawky twitches of the punk movement attracted our attention; given *Sounds*' lowly sales status, we were up for anything and pushed punk hard. It was like dynamite when the call to the punk barricades came, via blurry xerox'd flyers for midnight gigs in bizarre and exotic locales—a disused warehouse, a transvestite club, an X-rated fleapit cinema. In such arcane venues, the weirder the better, the new punk groups pictured here—The Sex Pistols, The Clash, Siouxsie and the Banshees, or The Raincoats would play to a frenetic audience that by next week might be on stage themselves.

We were making it up as we went along. No rule book, no how-to manual, was relevant. That celebrity wrangling could be a profession was unimaginable. There was no velvet rope back then, unless it was used to tie your bondage pants, and no separation between the group and the crowd. The Clash epitomized that hierarchical breakdown when they invited fans backstage or let them travel on the tour bus. Barring the odd ear getting bitten off (stand up, Shane of The Pogues, whose lobe was untimely trimmed in an incident at the 100 Club), security wasn't the issue it is now. It didn't take long before the do-it-yourself ethos of punk—slash it, burn it, stick it with a safety pin,

and then flog a fanzine about it—had raged up and down the motorways and touched every corner of the Disunited Kingdom. Before Nike Incorporated's Just Do It, DIY was punk's DNA.

The mid-seventies London streets were restless. Not that it was as brutal as America today, home of drive-bys and school yard massacres. There were no guns, but there was a lot of hard street action, between punks and skins mostly, and between the fighting fascists of the racist National Front and their sworn enemies, like Southall's collective of Misty in Roots and The Ruts, and Jimmy Pursey's Sham 69. Brawls became action and the resulting organization, Rock Against Racism, harnessed popular music against the National Front, broadly and on a grassroots level. JB shot all sides, from the heedless kid giving the Nazi salute to the radical reggae collective (and favorite of the late, eclectic British DJ, John Peel) Misty in Roots—they used music as a weapon, as the Nigerian musical revolutionary Fela Anikulapo-Kuti put it.

A dropout from the pretty hills of Hampstead, JB flourished in this spontaneous scene. After attending the arty King Alfred School, Beckman trained at the London College of Printing, then a hotbed of libertarian lefties whose other alumni include Neville Brody, etc. Her stubborn empathy with the outsider fed a roving indie spirit that led her to swap leafy lanes for a South London squat, while she trained her curious lens on tribes of all kinds. "I used to spend the time waiting for the musicians shooting the fans. I thought they were just as interesting," proclaims the populist lenswoman, whose ideology was in total tune with the punk zeitgeist. "I liked poking my camera in where it wasn't supposed to be." That transgressive bent served her well among the flamboyant underclasses she loved to chronicle, always homing in on the human inside the extravagant ensemble.

For a couple of glorious years, London was the center of the cultural universe with its libertarian sense of enfranchisement. Anyone could do it, and it seemed like almost everyone did—and had fun doing so. At night, punks and dreads would rock together at shebeens, illegal after-hours drinking clubs, where the Jamaican DJs showed the Brits how to party—a lesson that would blossom again in warehouse and rave culture. Reggae became our tribal religion. Our high priests were great talents like Dennis Brown, caught by JB at Ladbroke Grove's school gym–like Acklam Hall with his bred'ren, singer Junior Delgado and Castro Brown, head of the DEB label. Their team also nurtured Britain's first indigenous black music—lover's rock, the heart-tugging girly harmonies of junior divas like the teenage trio 15, 16 & 17, whose "Black Skin Boy" (produced

by dubmaster Dennis Bovell) was the biggest sound around when JB shot them swaying across a frosty South London street in their big fur coats.

In her art student days, JB liked to dress the rebel rocker and twirl in a circle skirt. That experience illuminates her picture of a blissfully whirling rock 'n' roll girl, flashing her stocking tops and suspenders, lost in the pagan frenzy that got rock banned, back in the day. But in the arc of this book, JB consistently, evenhandedly displays her trademark empathy spanning the rise and fall of sequences of youth tribal styles—the fetishistic atavism of teds, the cool, crisp existentialism of the mods, reggae dawtas intimately knotting each other's head wraps (my personal fave), the zany communality of the 2-Tone girls doing the Madness Monkey Man Skank. She would soon bestow on us her series of early hip hop photos that became her first book, *Rap: Portraits and Lyrics of a Generation of Black Rockers* (with writer Bill Adler).

Yes, JB had moved from London to LES, NYC; but her vision remained that of the young soul rebel.

Quite apart from the art of it, JB and I still chuckle, frankly, at some of the more louche, outlandish memories the pictures evoke. Take the shot of John Lydon, hair ruffled like a cockatoo, requisite beer and fag (cigarette) in hand, flashing a jaunty, lopsided grin as he leans against the giant speaker of his Fulham home, doubtless vibrating in sync with some heavy, heavy dub music on the stereo. Though past his Rotten, Sex Pistols days, and into his avant-dub, progressive era with Public Image Ltd., Lydon still liked being Rotten—that night in the local Indian restaurant, he pissed into a beer glass that he thankfully held under the tablecloth. JB and I still feel bad for that poor waiter. Years before his early demise prompted his elevation to rock god status, JB caught Joe Strummer solo in the dressing room, stretching his arms in a meditative warrior pose. But she herself had to be a warrior to get that shot—and to evade the advances of Roadent, the infamous Clash roadie, who, mistaking her for a so-called "groupie," offered to let her backstage and get her any band member in exchange for a blow job.

Odd how, though that world is technically gone, it still seems so resonant. Rebellious or bonkers, punk attitude and spirit proved to be as permanent as a tattoo on music and youth culture; and though their numbers may be diminished, all of these tribes survive. Each of these fashions proved not only to reflect the realities of the day—but to act as archetypes that answer the often inchoate needs of succeeding generations of youth. And once a mod, rocker, ted, punk, or soul rebel, you don't stop.

Vivien Goldman

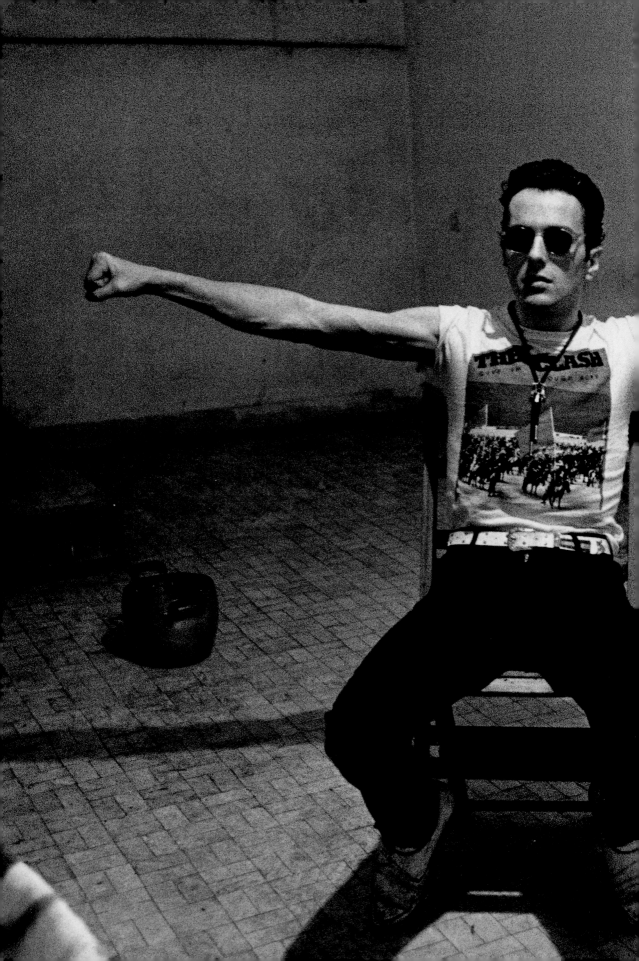

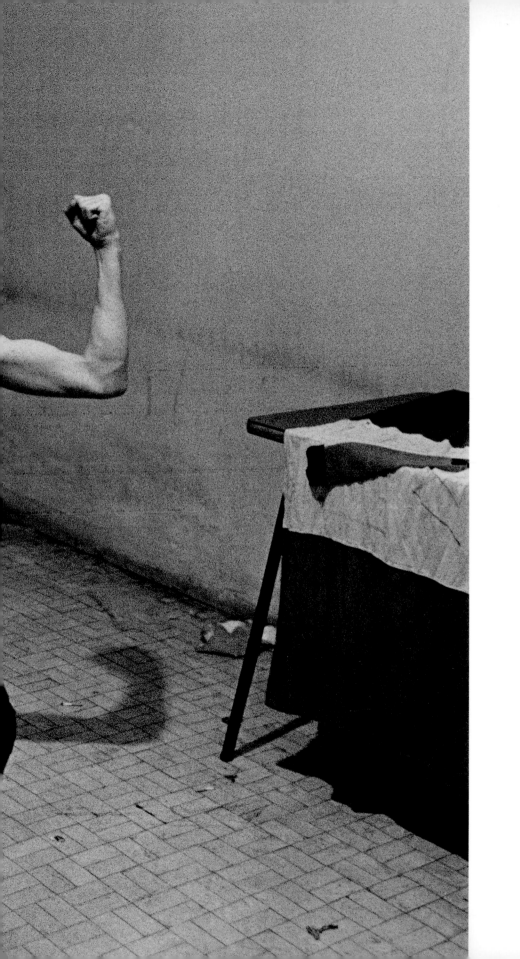

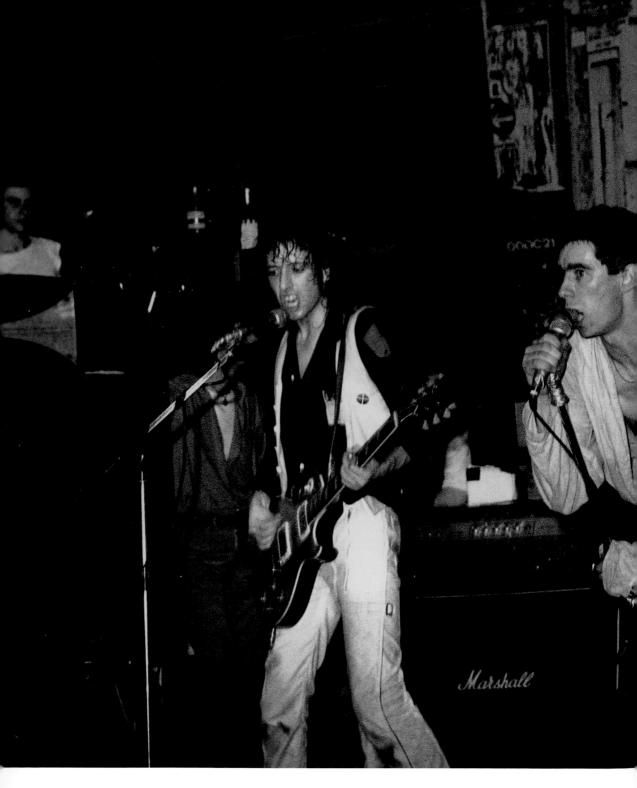

" White riot, I wanna riot, white riot, a riot of my own!"

The Clash

"'Anyone who thinks violence is tough should go home and collect stamps.' Yes, those were the exact words I said, but what I was really trying to say could have been said much better. What I meant was—the toughest thing is facing yourself. Being honest with yourself, that's much tougher than beating someone up. That's what I call tough."

Joe Strummer, The Clash

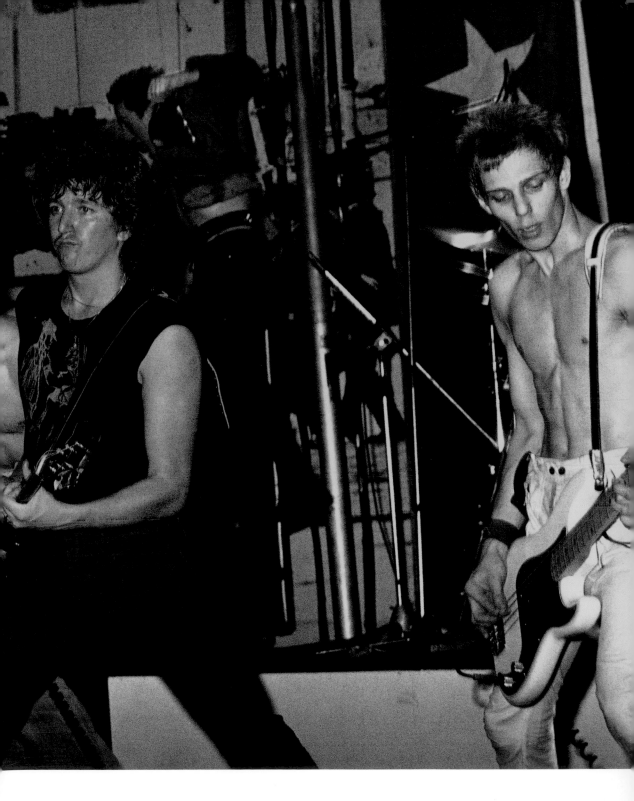

"What is it about punk rock that is so important to Joe? It's
the music of now. And it's in English. We sing in English,
not mimicking some American rock singer's accent. That's
just pretending to be something you ain't.
Caroline Coon, *1988: The New Wave Punk Rock Explosion*, 1977 **"**

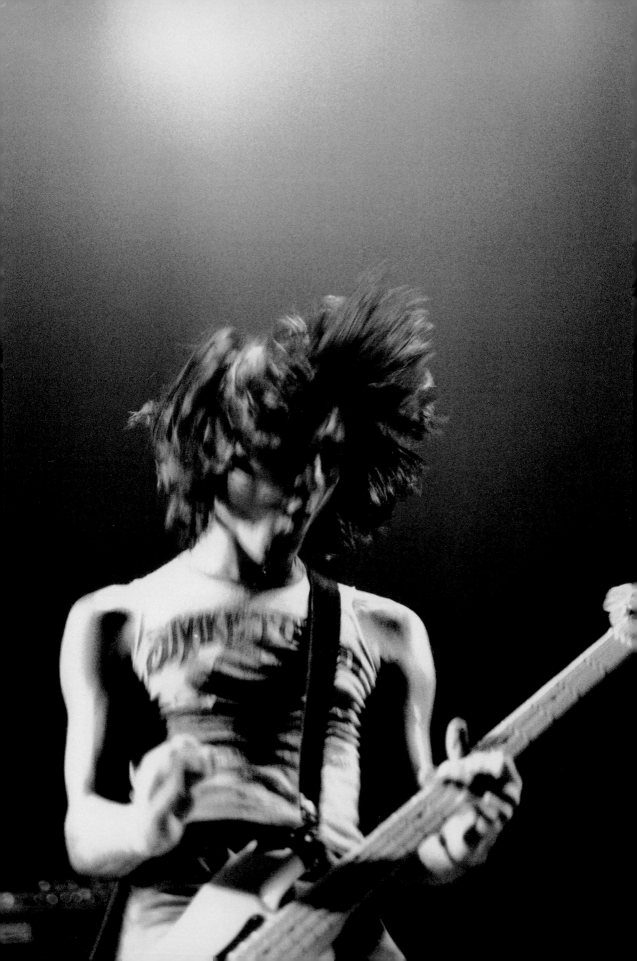

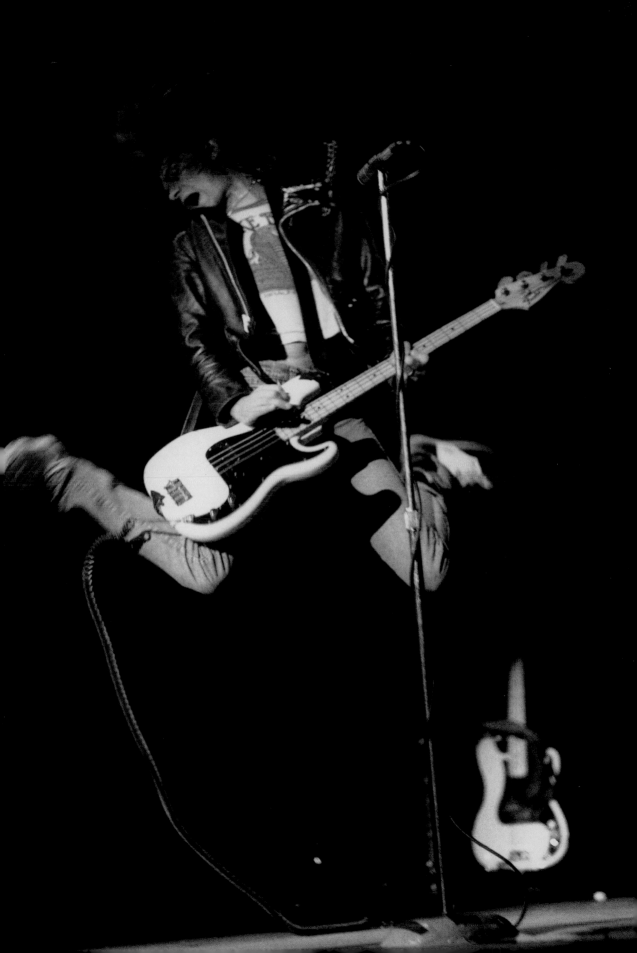

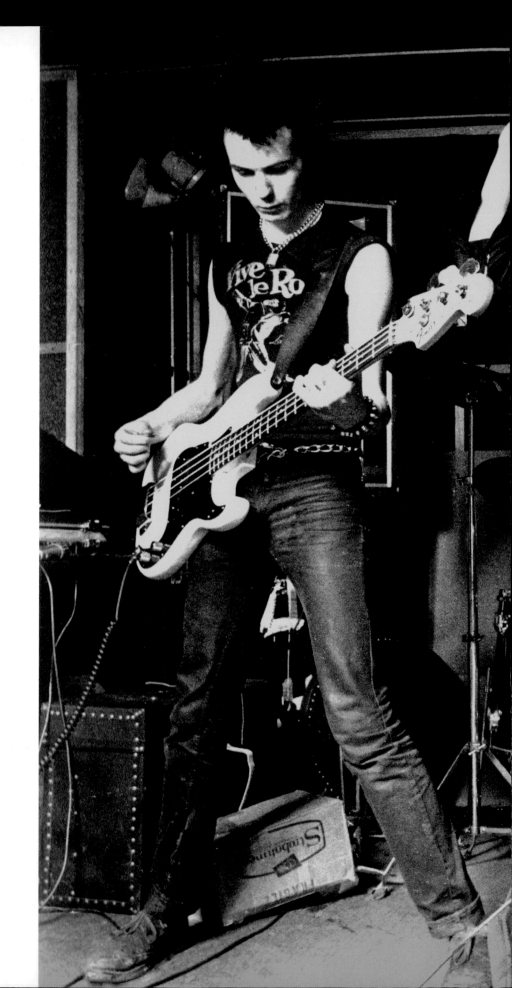

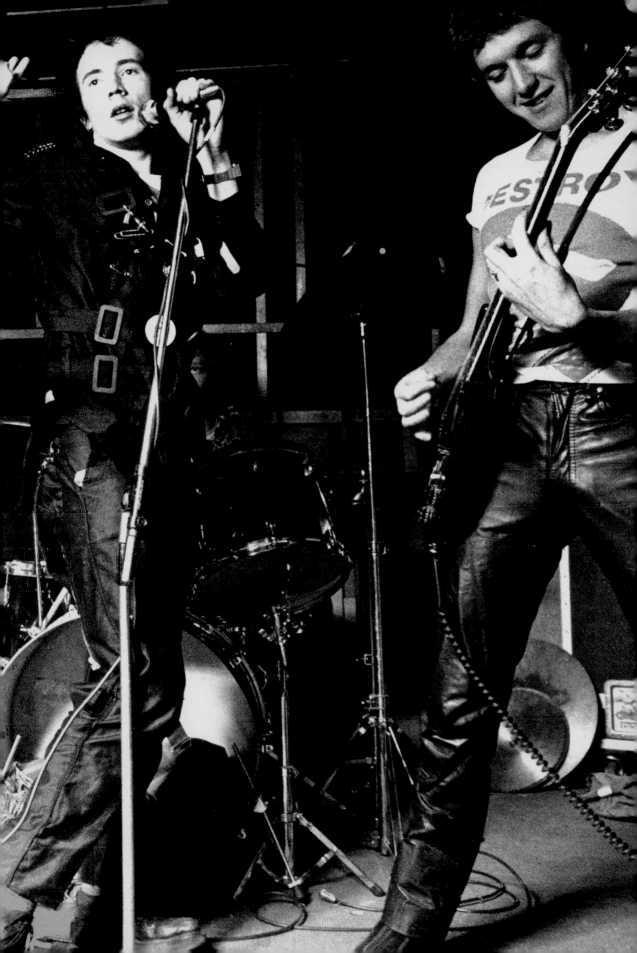

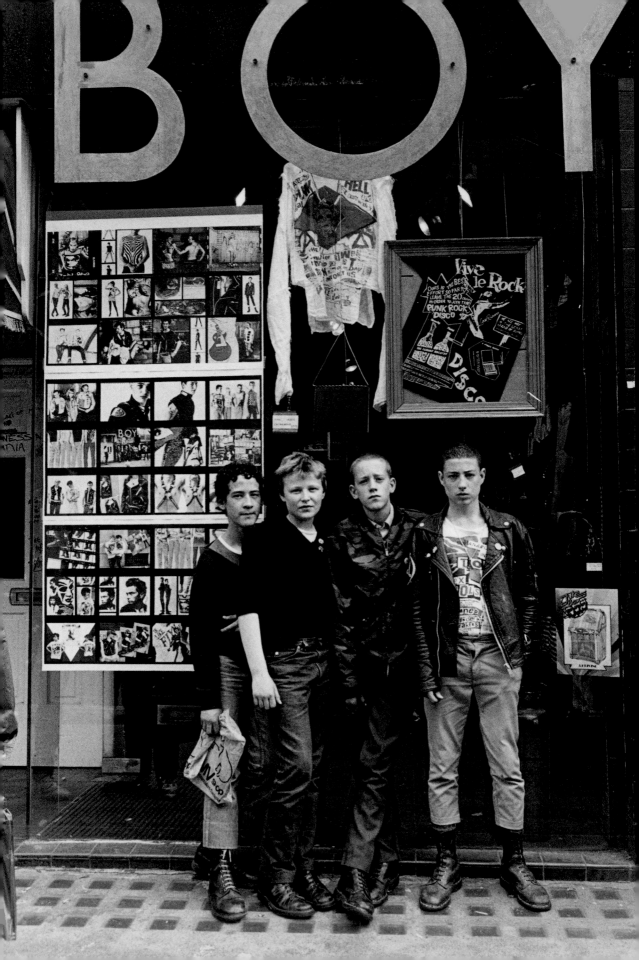

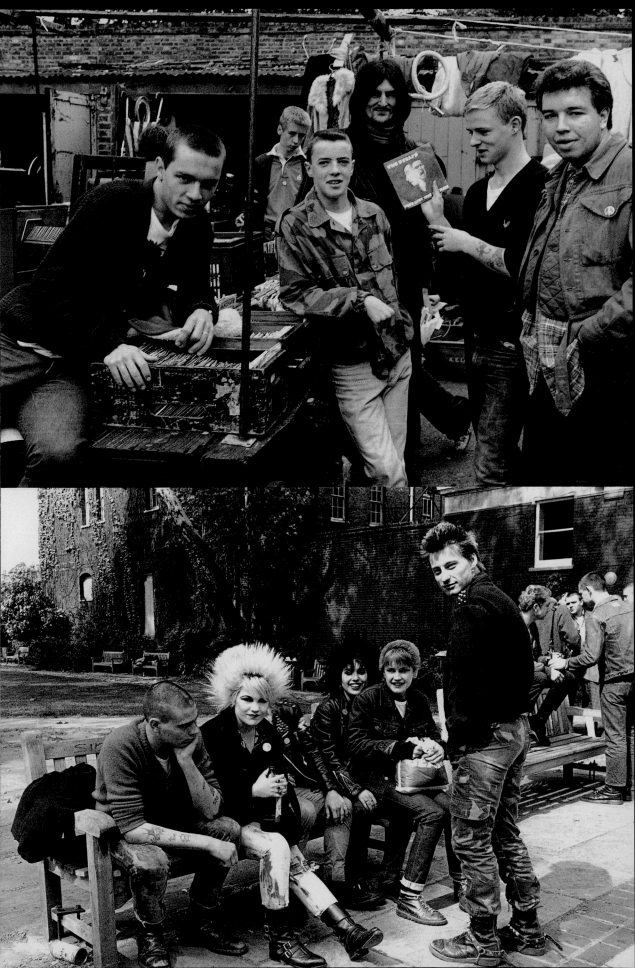

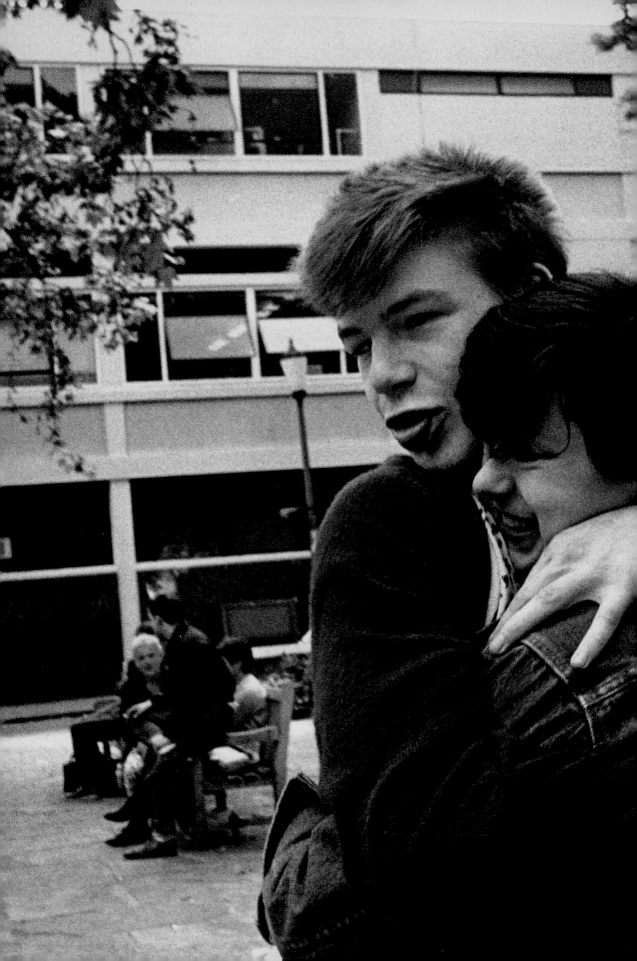

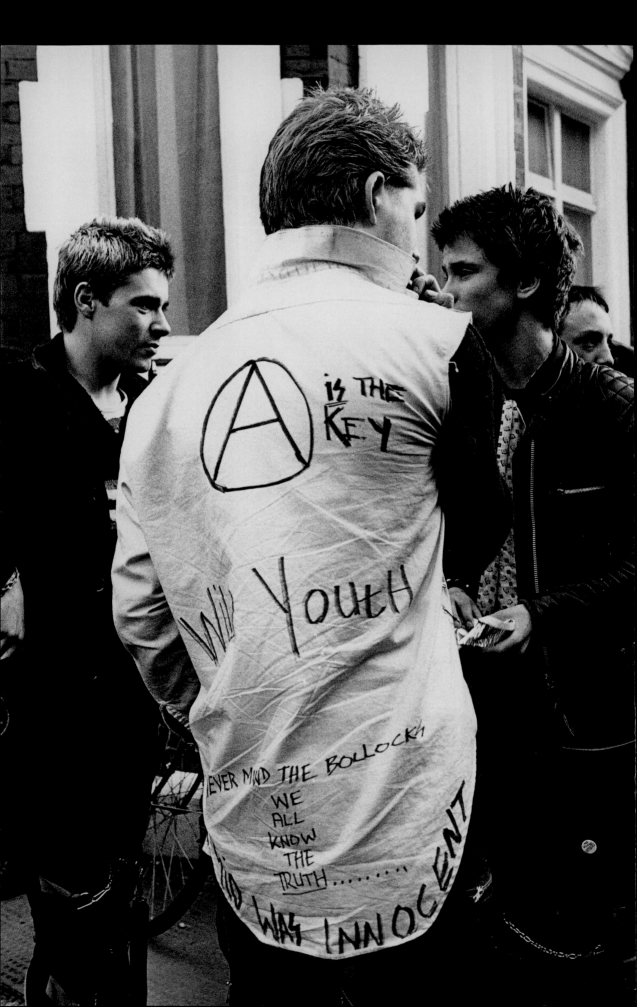

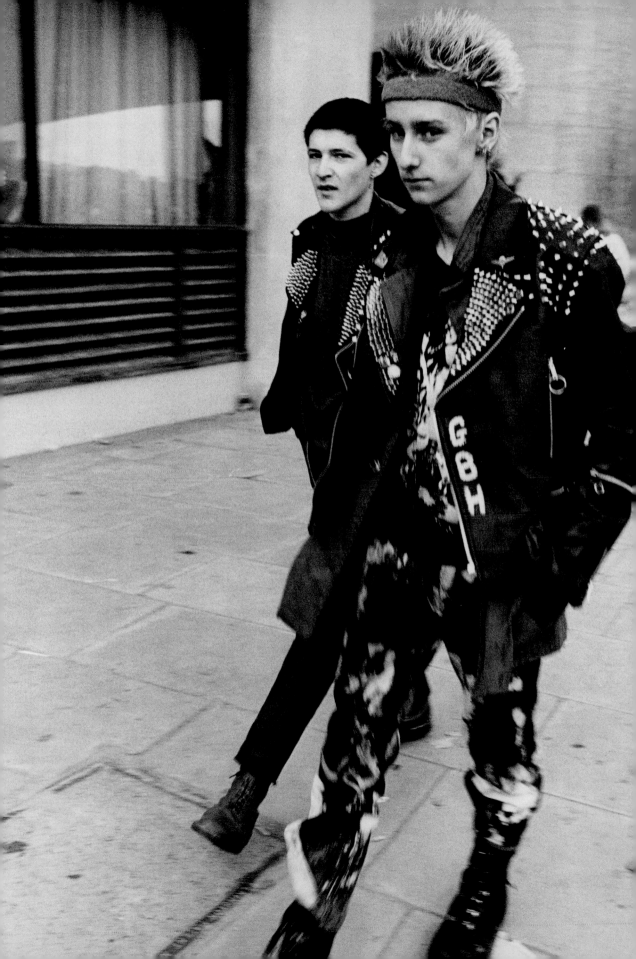

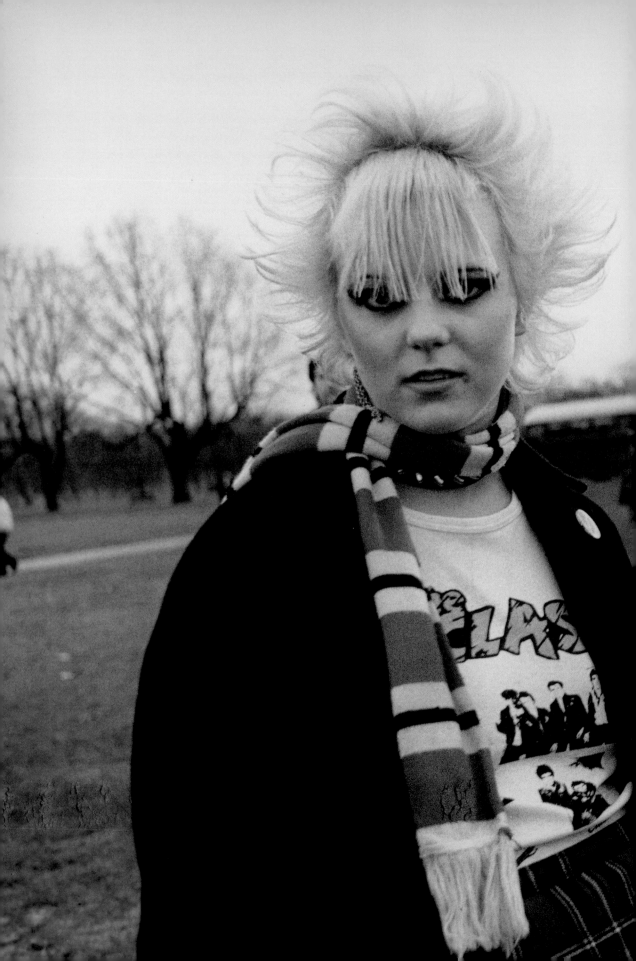

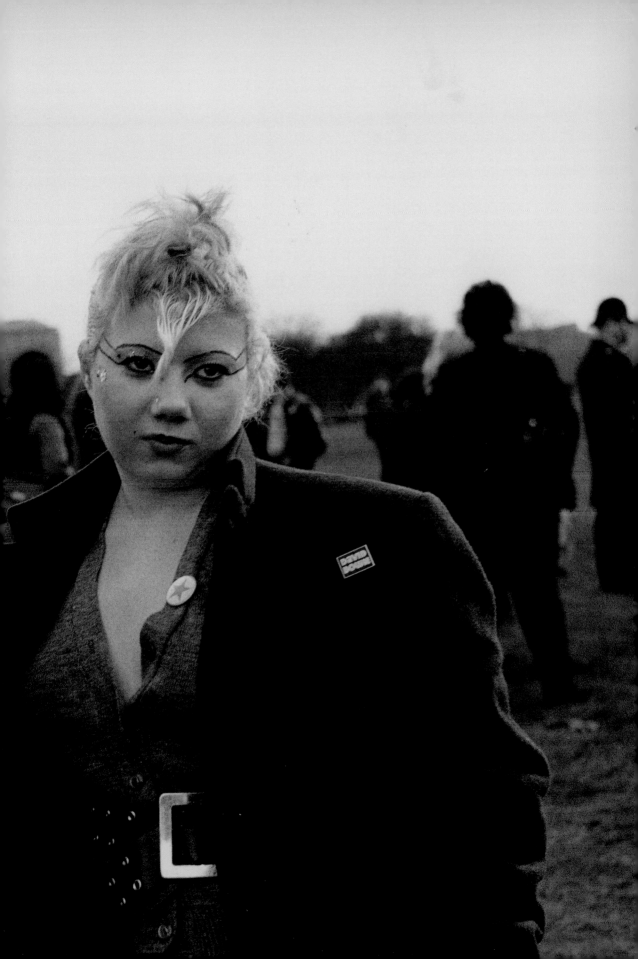

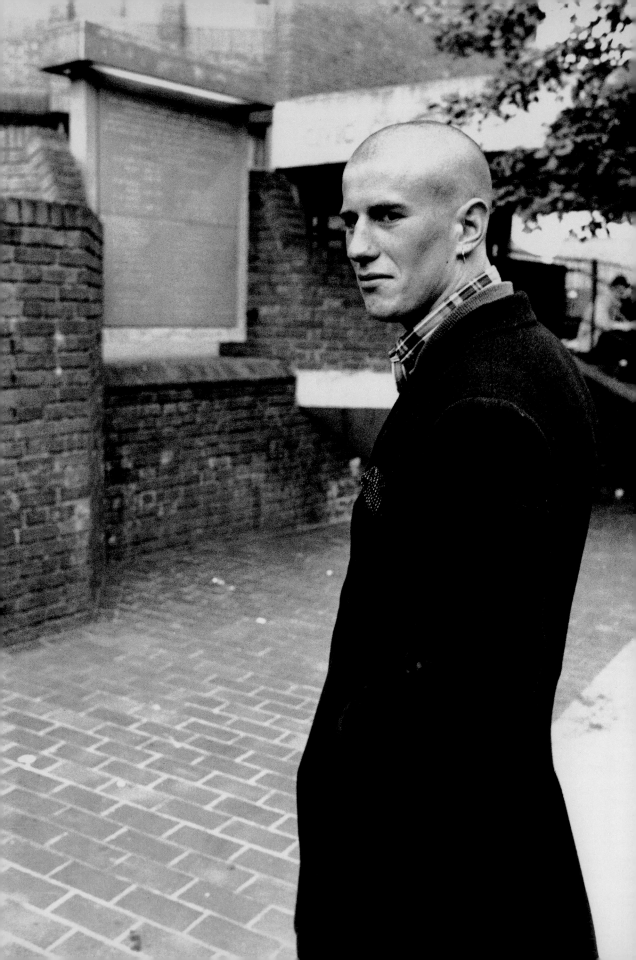

" A skinhead had the harsh brilliance of self-respect.

"Button-down Ben Shermans, white or pastel Levi's Sta-Prest or bleached denim, half-inch turnup just above the boot—ten-hole Dr. Martens or cherry-red, steel-toe cap. The style was vaguely militaristic; American college boy neatness coupled with Jamaican rude boy flair, compounded by English wide-boy flash—soundtrack by The Upsetters, Dave & Ansel Collins, Prince Buster, and Desmond Dekker.

"Attitudes were aggressive, individualist, reactionary, but predominantly apolitical. Class consciousness was the major factor.

"The swastika, already adorning many a punk T-shirt, was flaunted in the form of facial tattoos and the public was taunted with Nazi salutes.

"Skins were drawn to bands such as Screwdriver, Cockney Rejects, and Bad Manners. These bands would play their sets regardless of fight or, in the case of Fat Man Doug Trendle—the front man of Bad Manners—would wade in and sort out the rucks himself.

Nick Knight, *Skinhead*, 1982 "

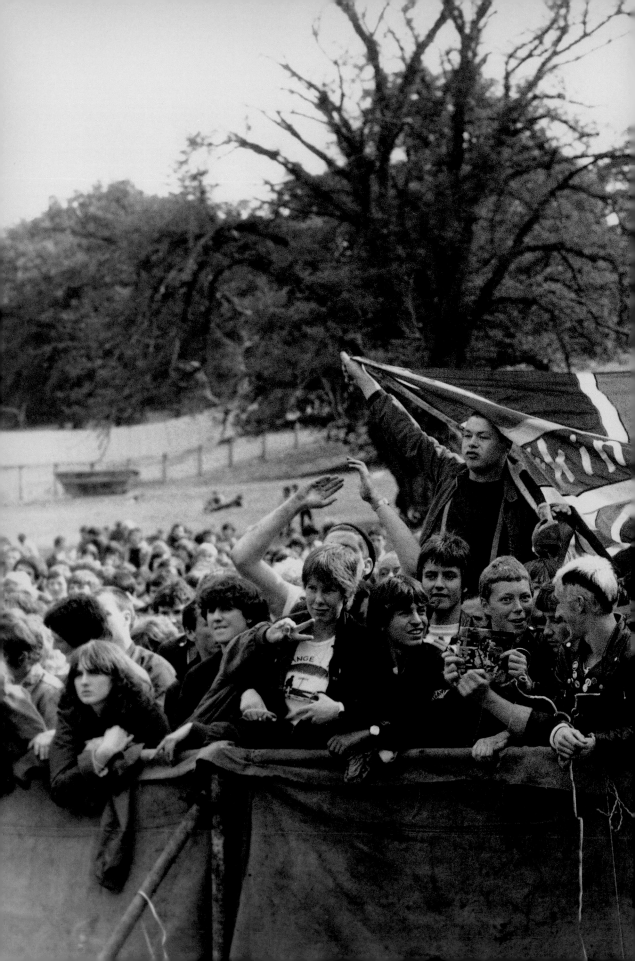

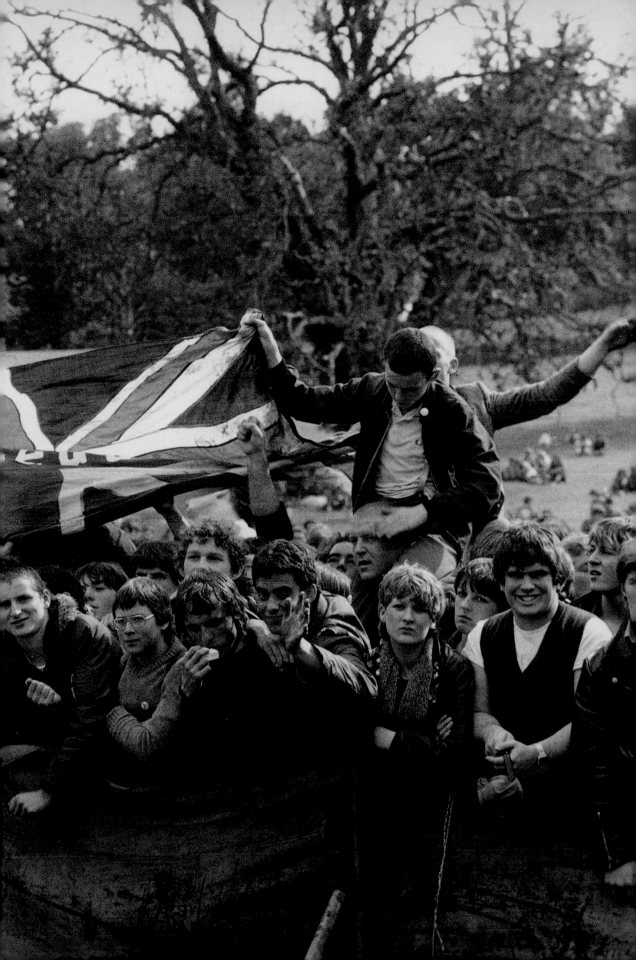

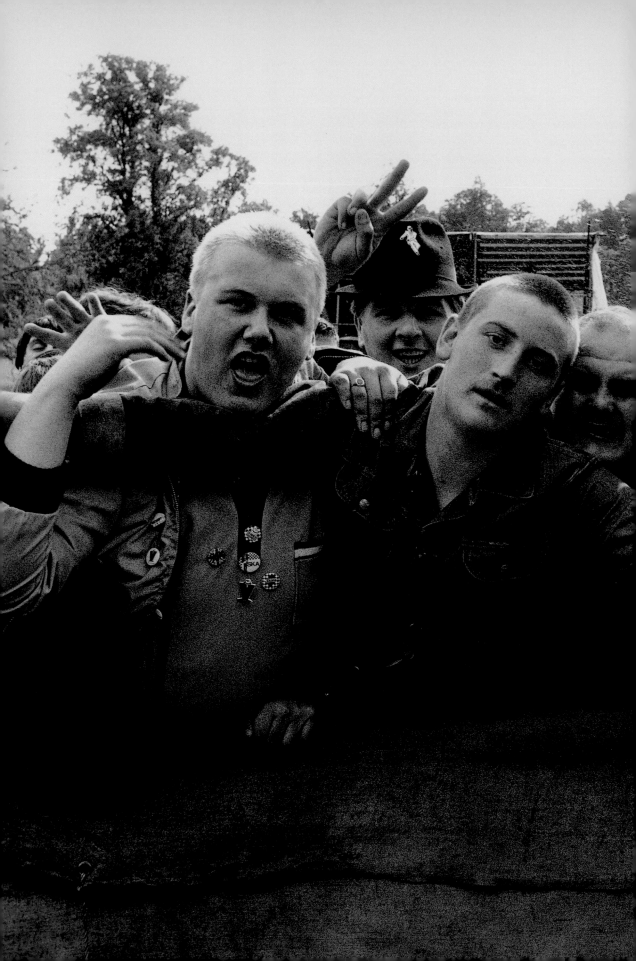

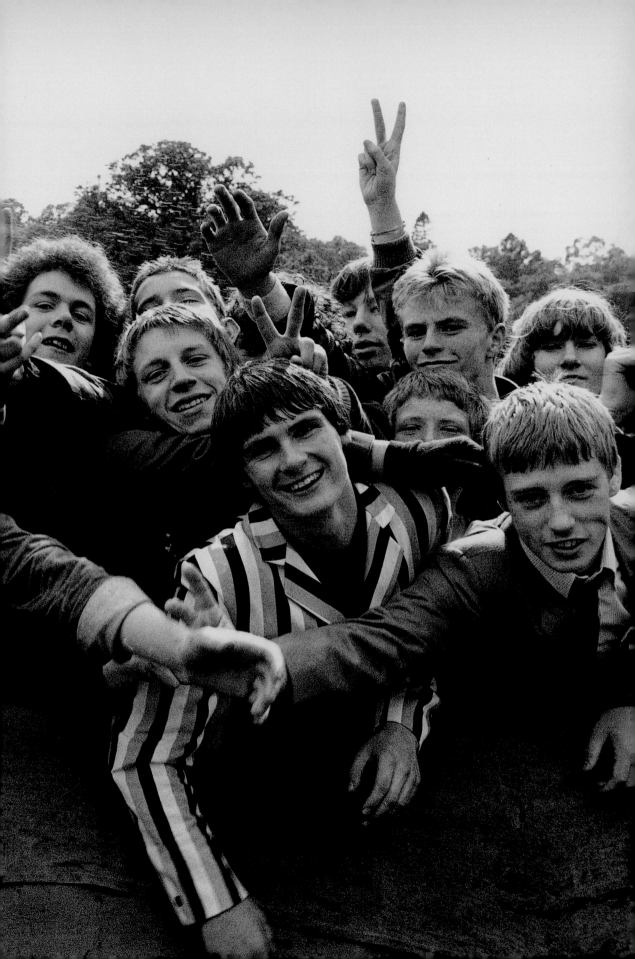

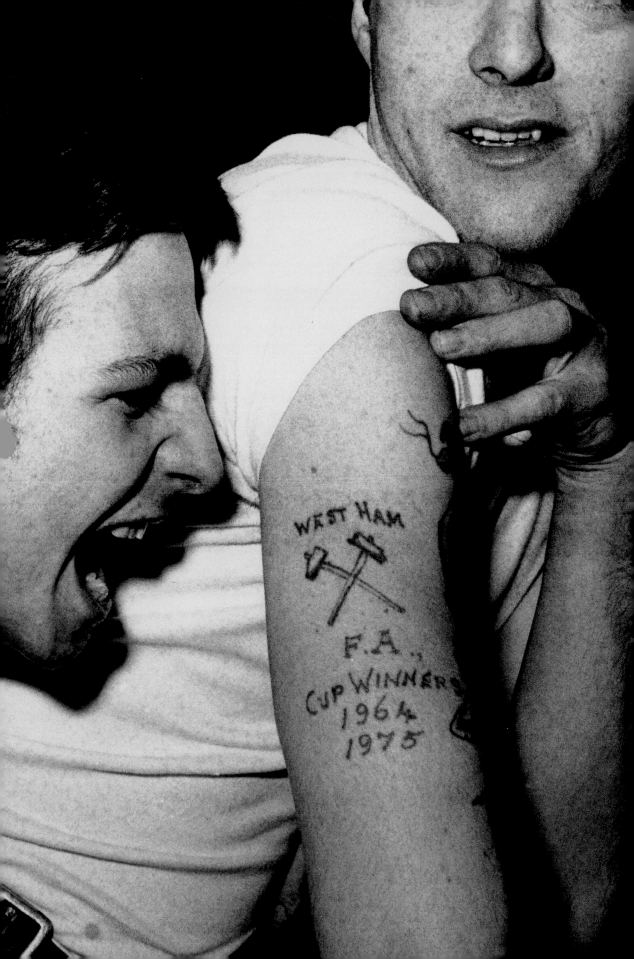

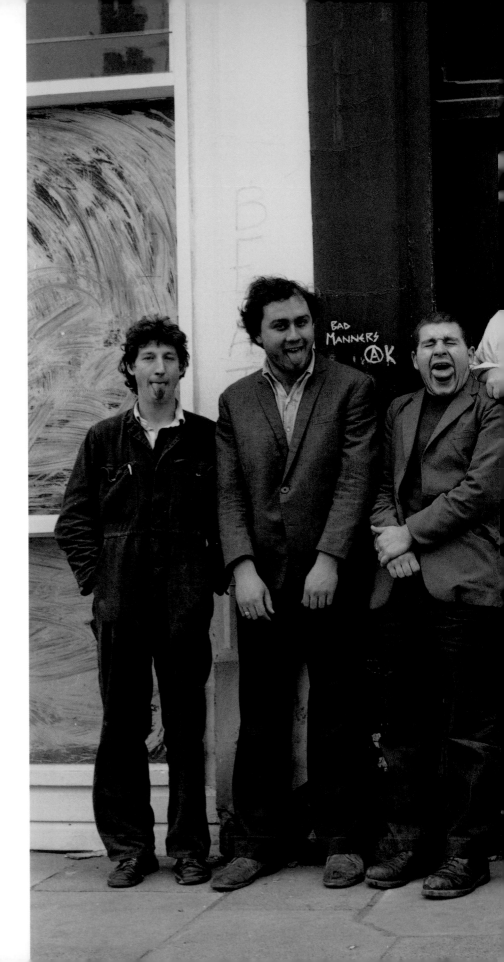

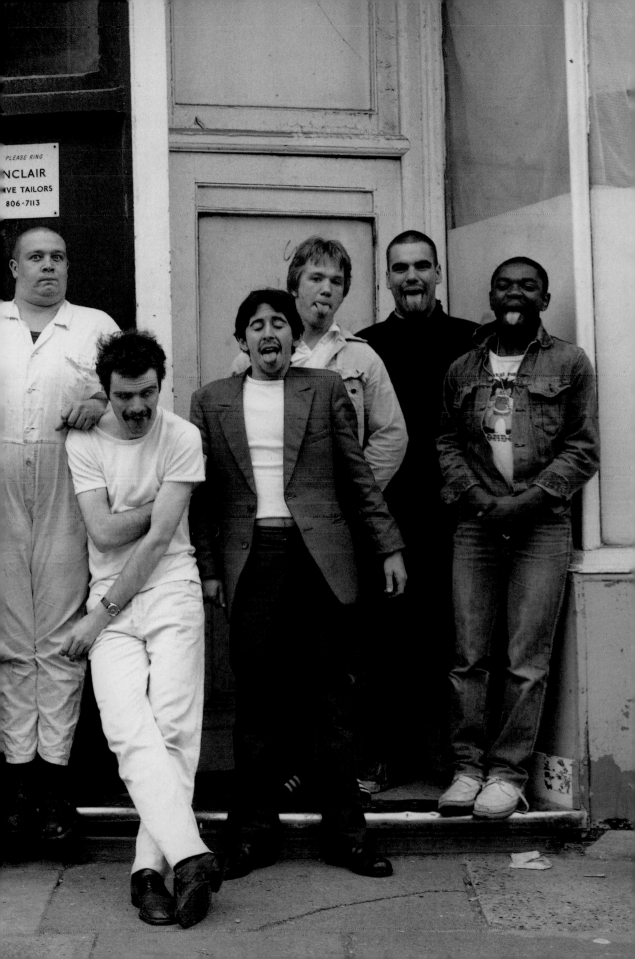

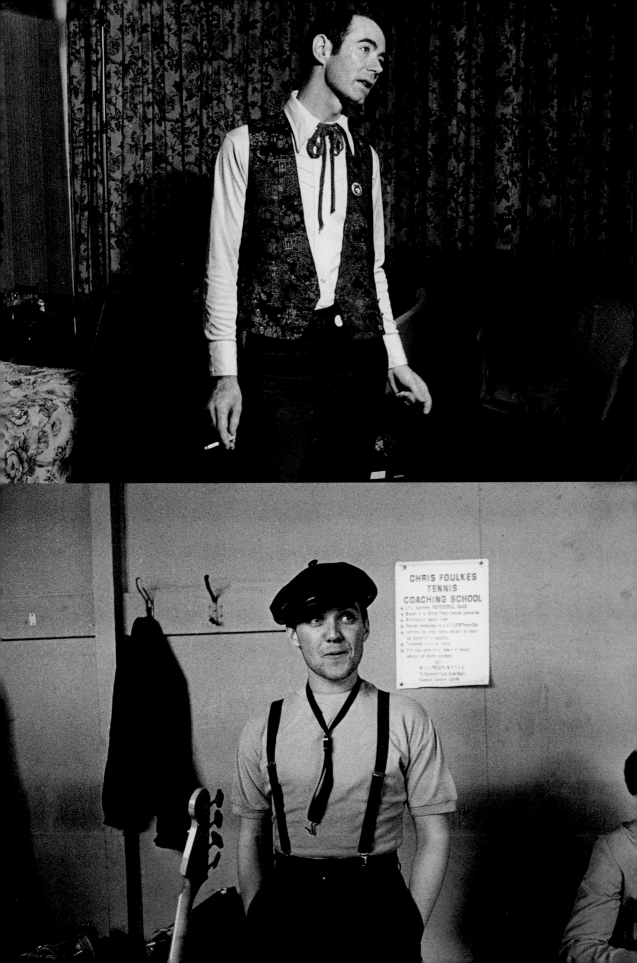

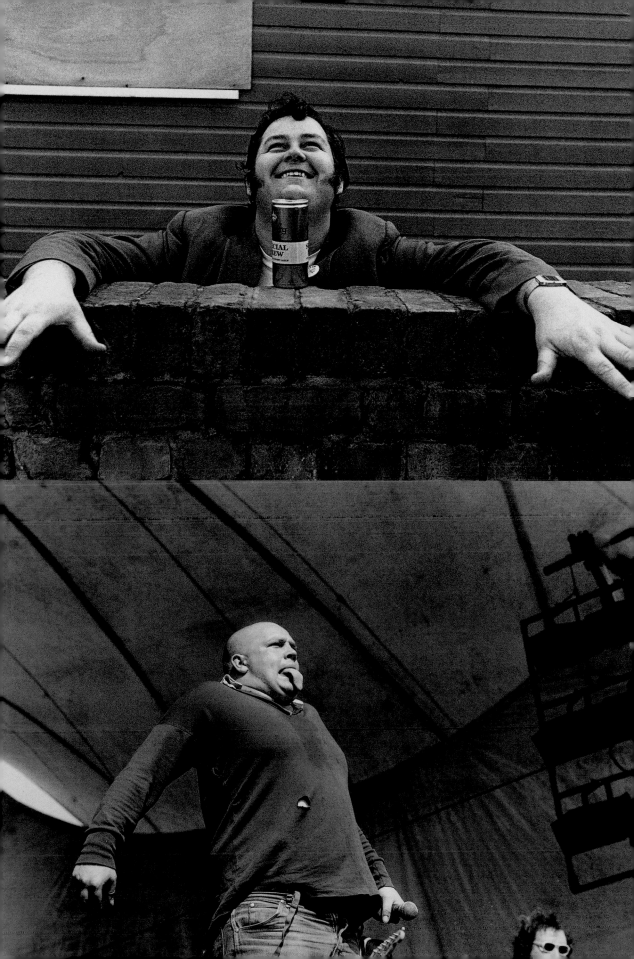

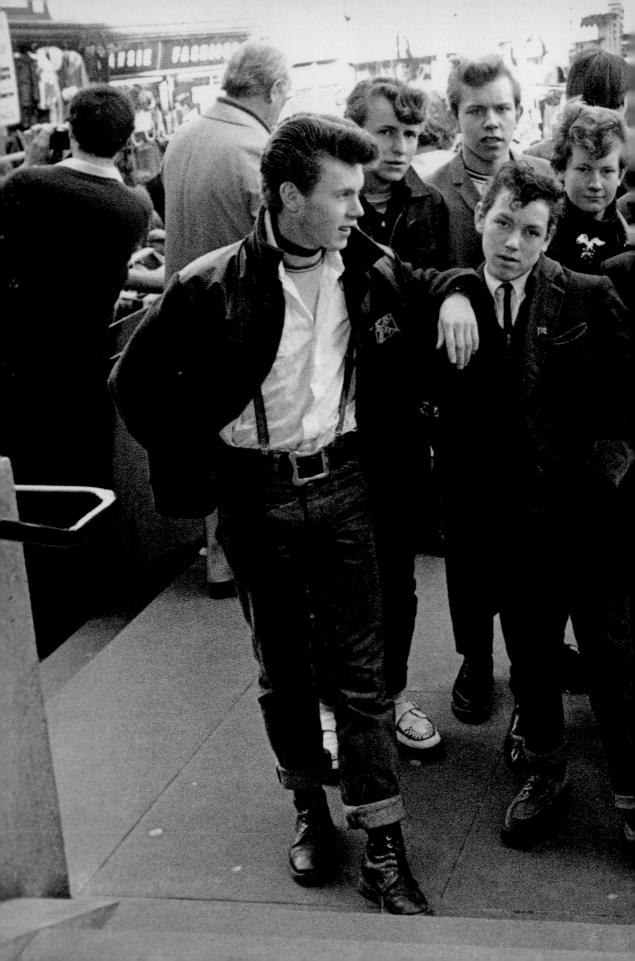

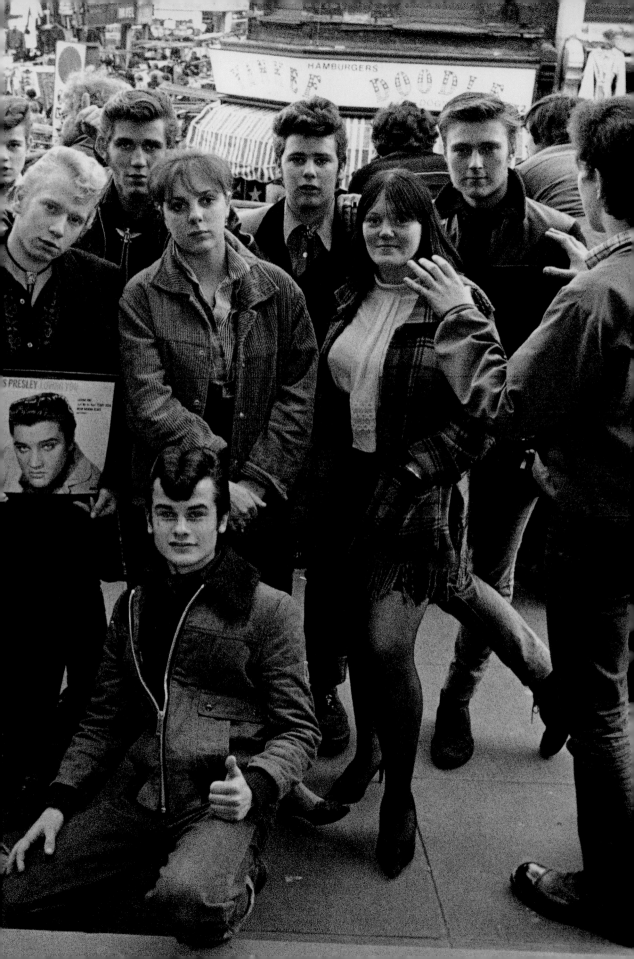

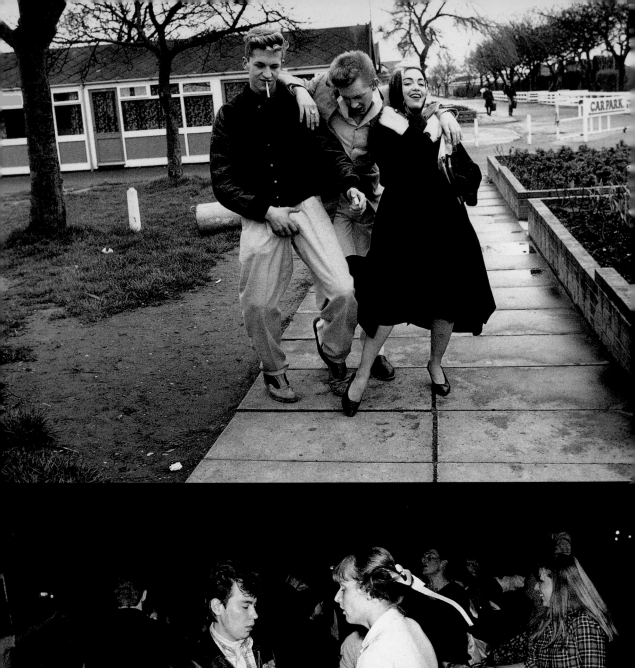
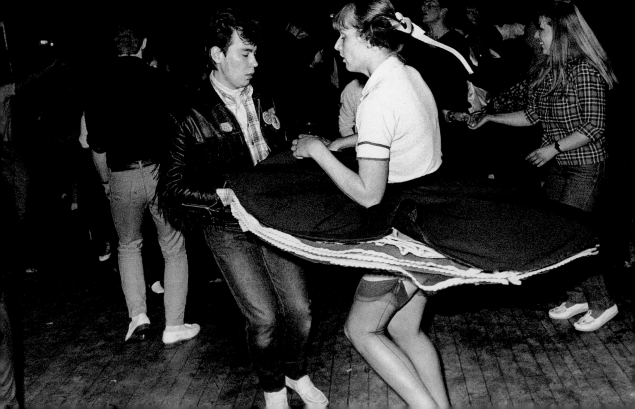

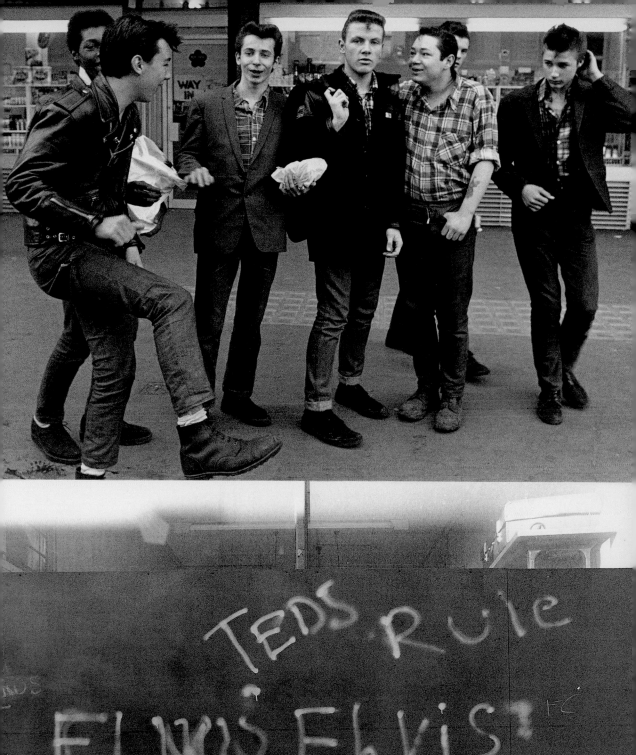

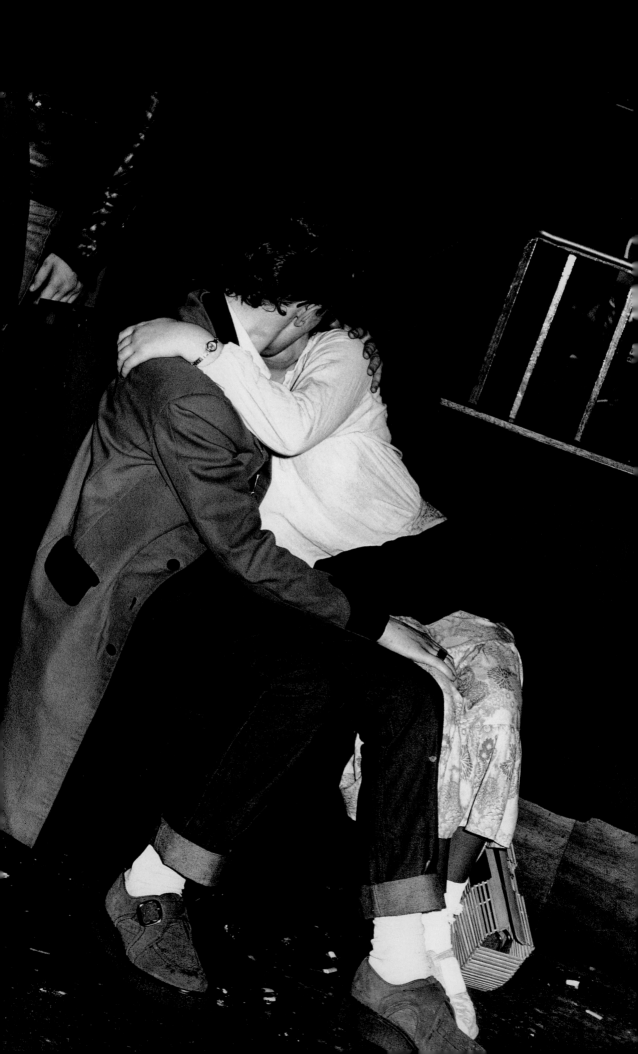

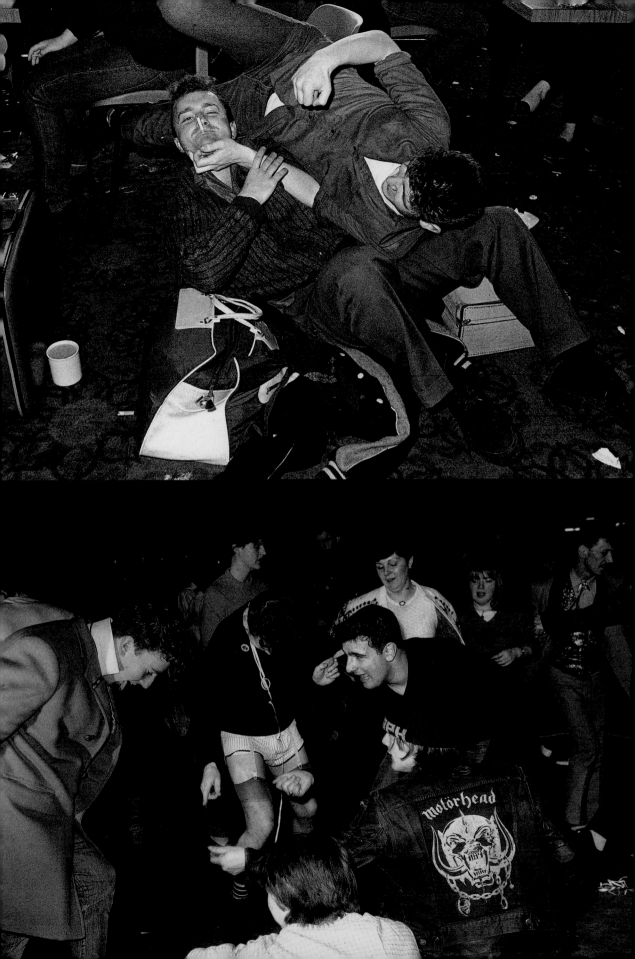

" In about '79 [The Rockats] moved to New York and became the toast of the town, shagging everything that moved and inspiring a plethora of rockabilly outfits, such as The Stray Cats."

Chris Sullivan,
*Punk: The Definitive Record of a Revolution*, 2001

"Although The Rockats couldn't play, it didn't matter, they were great and they looked good and had all the attitude."

Robert Elms,
from *Punk: The Definitive Record of a Revolution*, 2001

"Recipe for hair success: Brill cream sides and Black and White top. And if you want it high? Use Murray's in the red tin."

Chris Horsfield, rocker

"Quivering and swaying to some silent rockabilly beat running through his soul, Stray Cats bassist Lee Rocker stands in front of the mirror of the Liverpool hotel bedroom he shares with drummer Jim Phantom and plasters his hair with a handful of urine-colored pomade, working up with his fingers and metal comb an elaborate sausage-roll quiff.

"He sets in place the final piece of tonsorial sculpture with an aerosol blast of lacquer that mingles with the grease to create a chemical mixture that probably can only be shampooed out with paint stripper.

"On the floor on his hands and knees, Phantom spreads a damp bandanna over a pair of black peg-leg pants and, with dry ice–like steam arising about him, irons out the suitcase-created creases, readying his wardrobe for this evening's show in a couple of hours' time.

Chris Salewicz, *NME*, March 1981 "

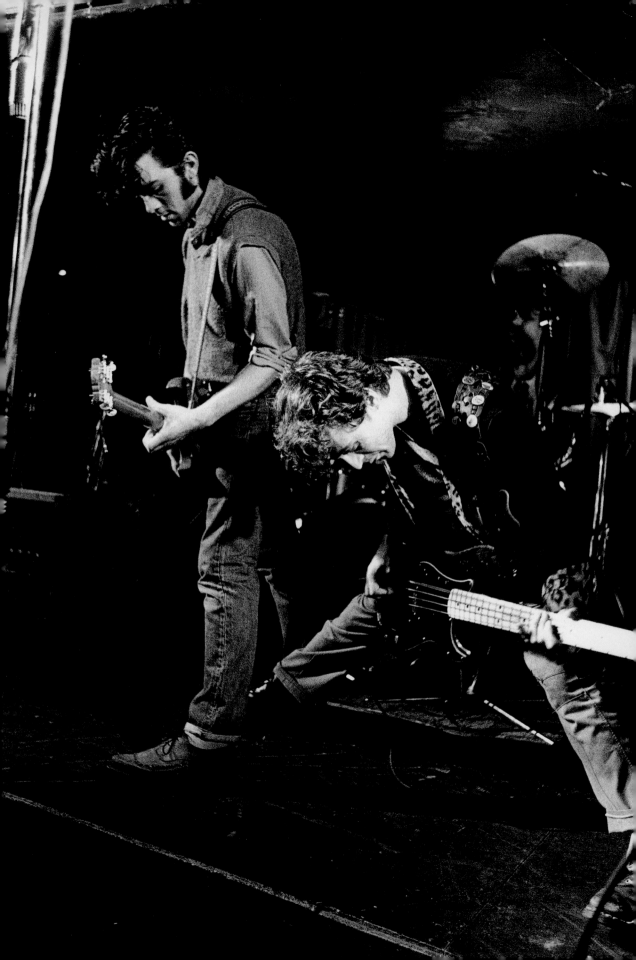

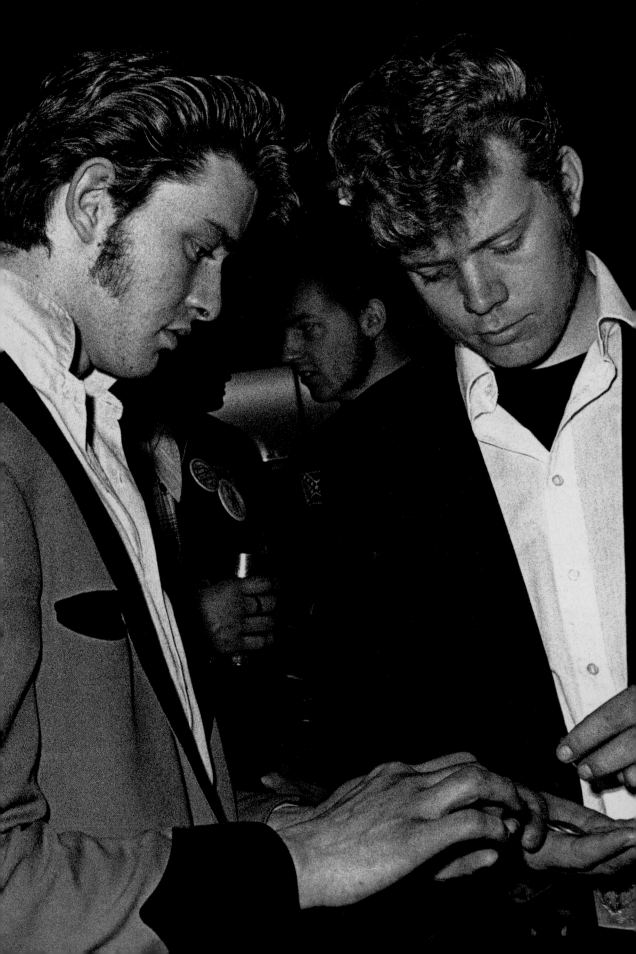

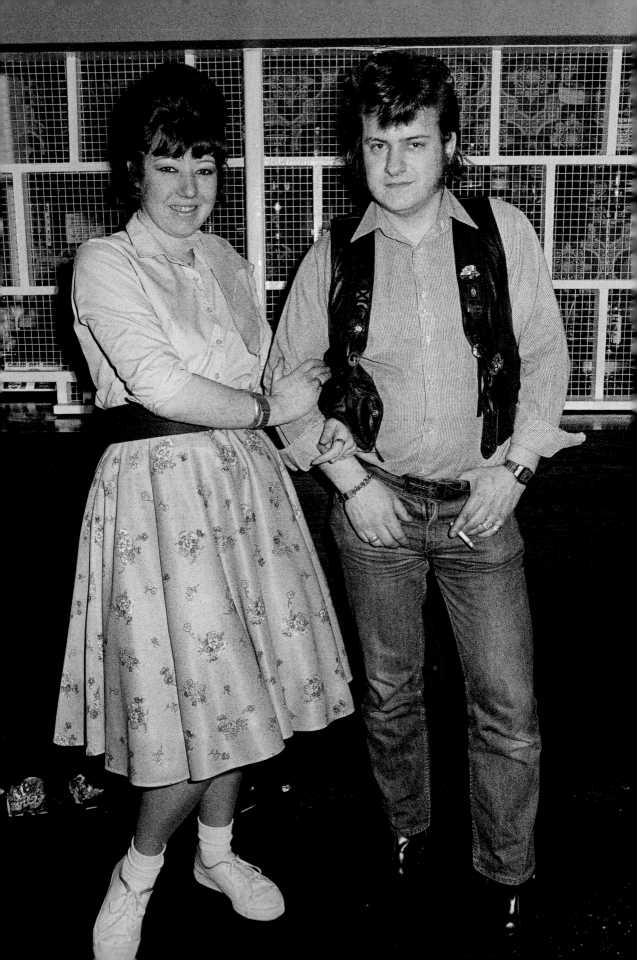

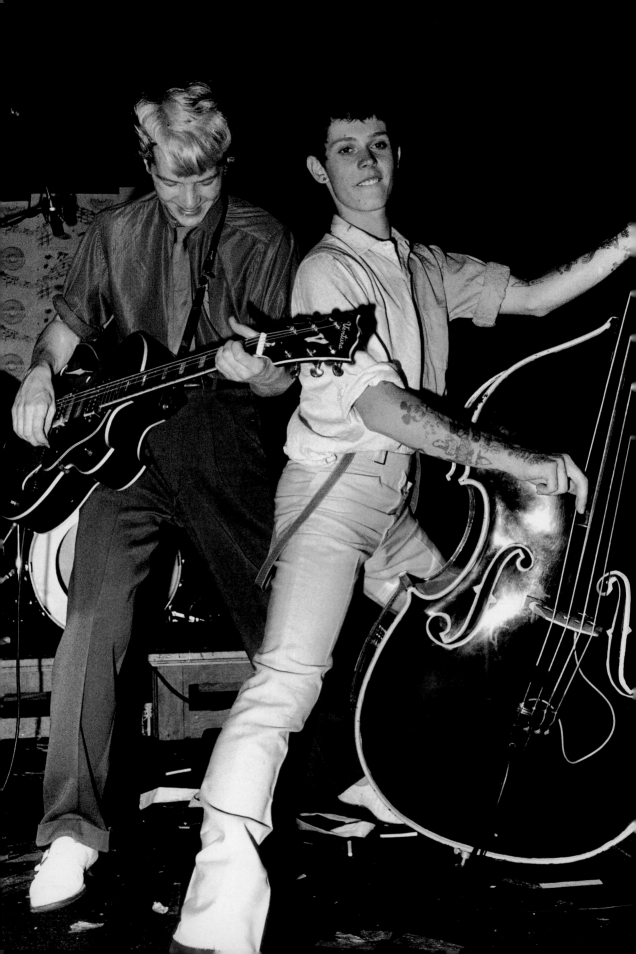

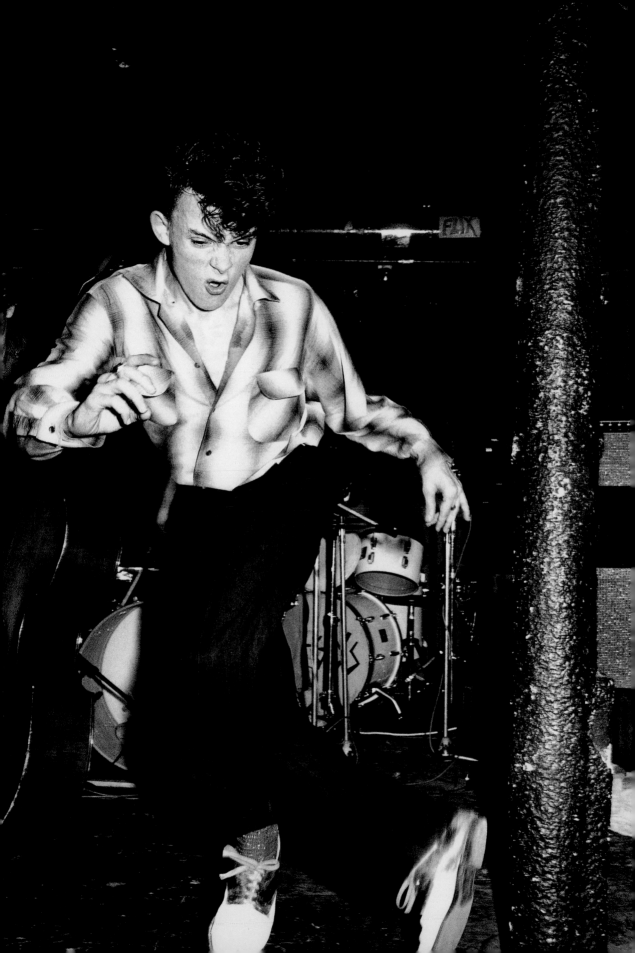

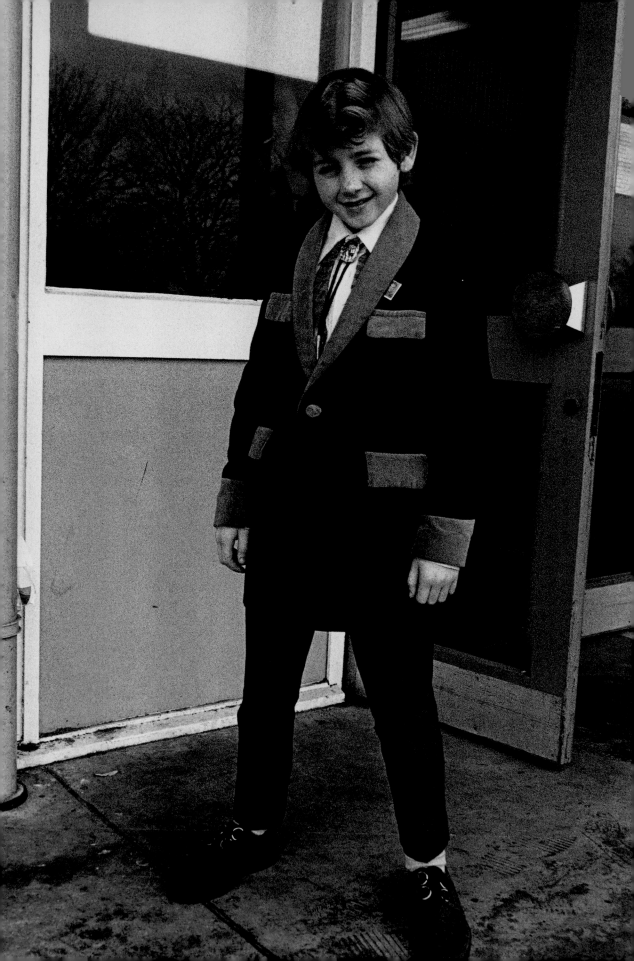

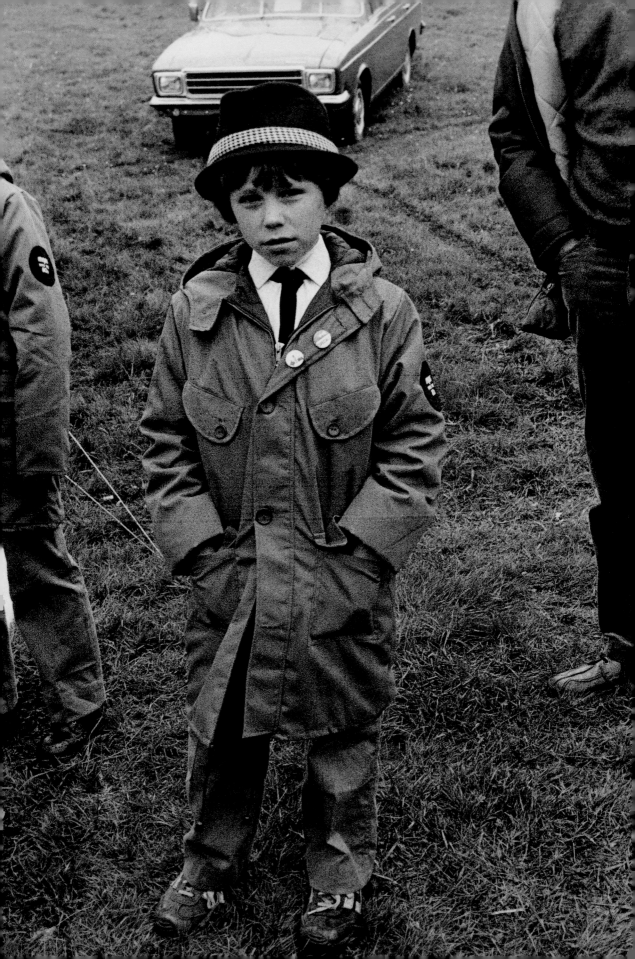

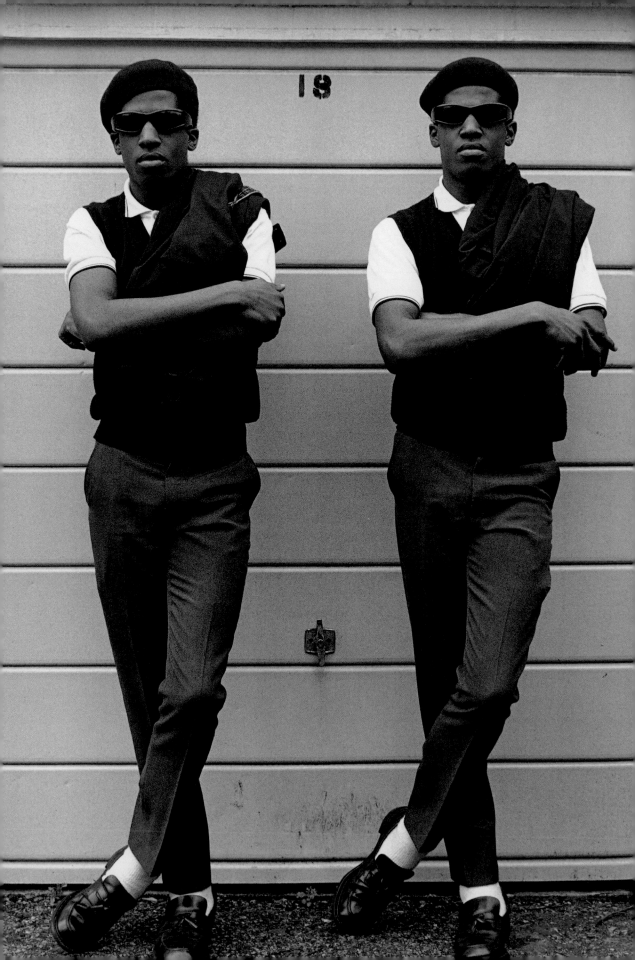

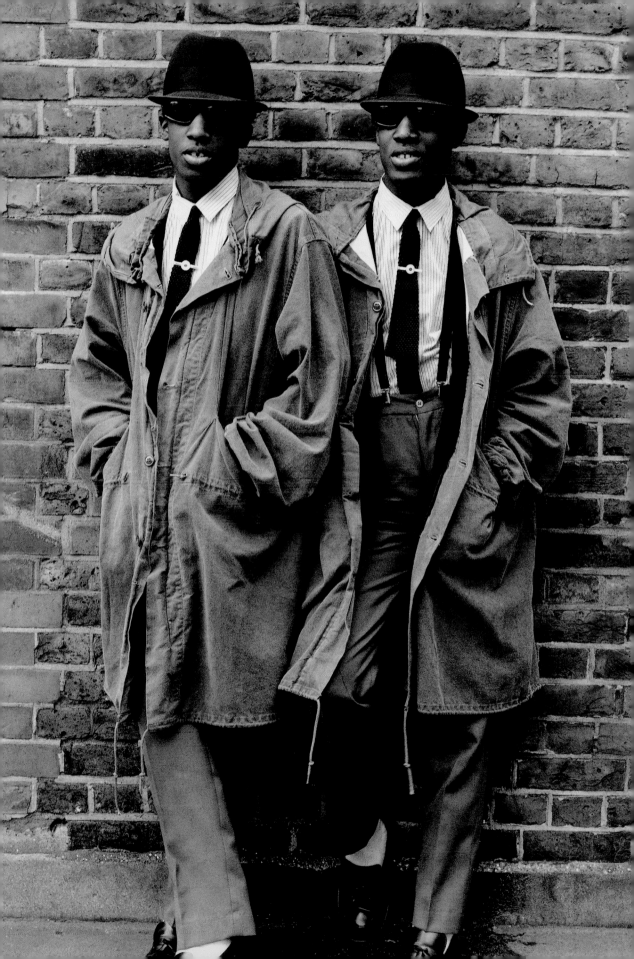

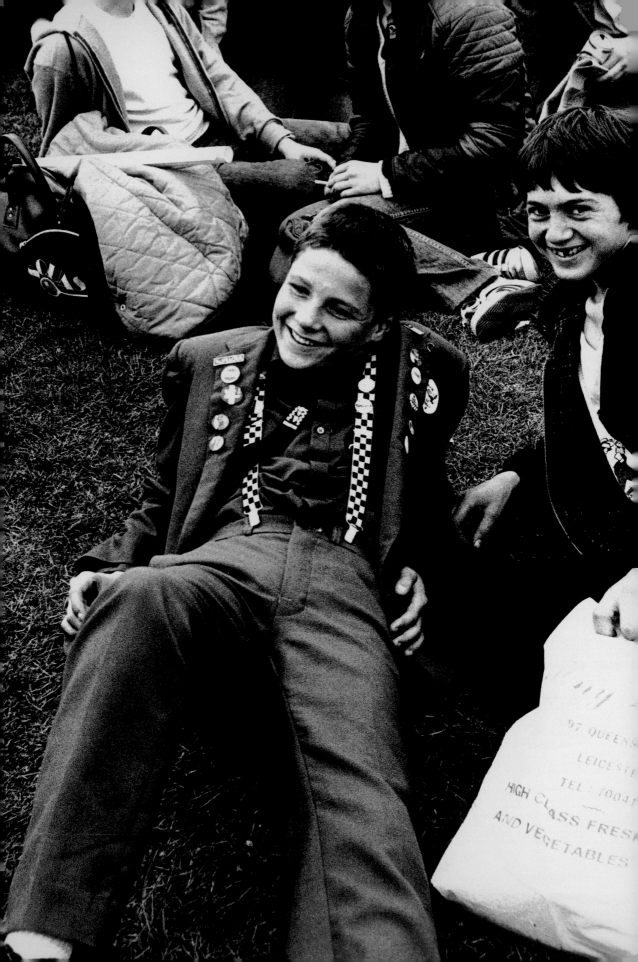

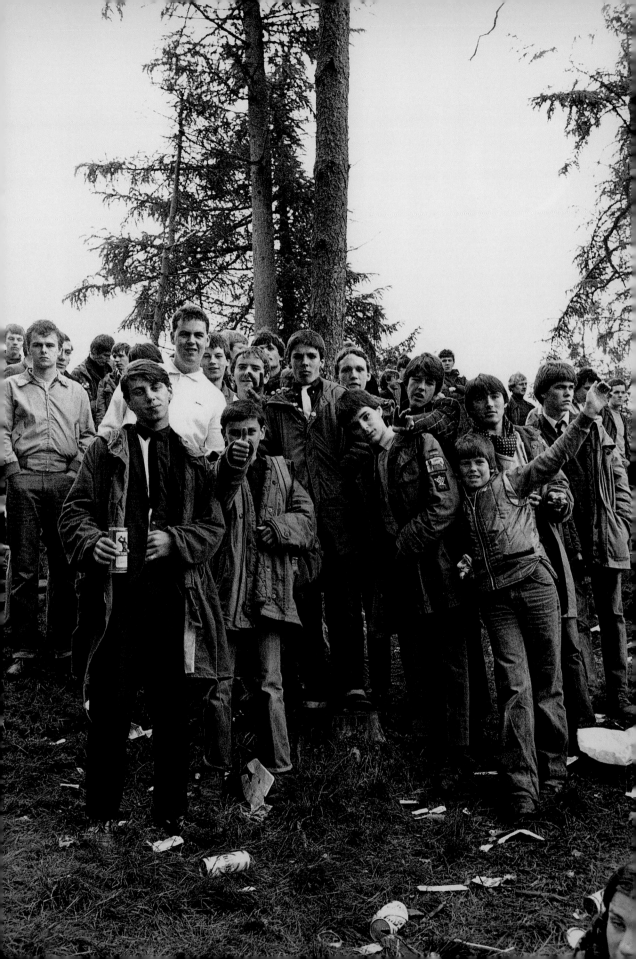

"A Lambretta with whitewall tires, it's a perfect product and it's from Italy."

original mod

"Mod girls were very stylish. They wore white lipstick, really severe haircuts, polka dots, white stockings, big plastic jewelry, and very short skirts with a big wide belt.

original mod "

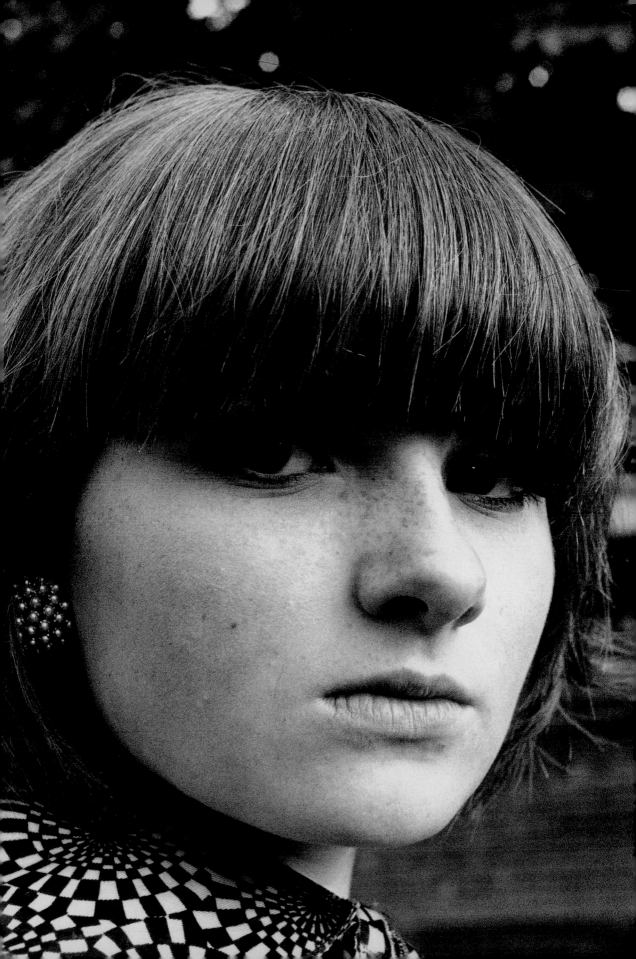

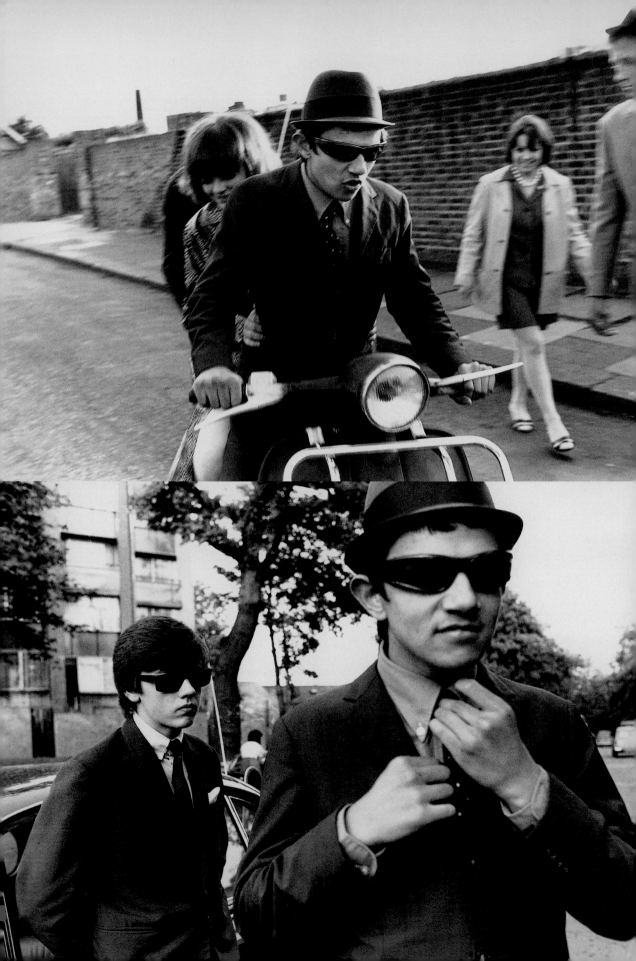

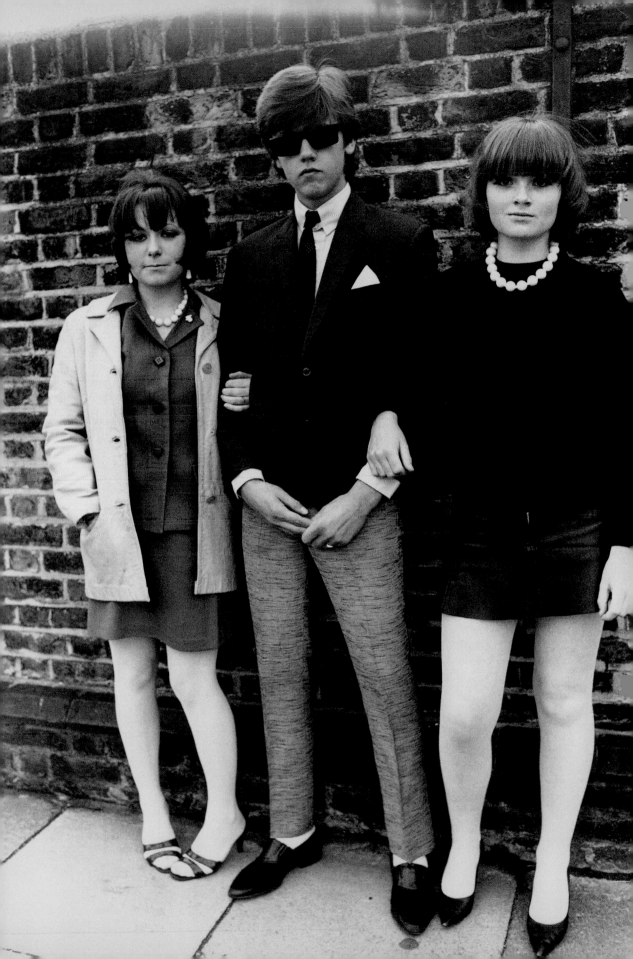

After punk had blown itself up through a mix of unsustainable promises and widening musical ambitions, Britain's musical landscape experienced a massive surge in activity.

All kinds of genres came to the forefront. There was the art avant-garde, led by bands such as John Lydon's Public Image Ltd., Joy Division, Echo and the Bunnymen, and The Teardrop Explodes.

New wave music prospered through Elvis Costello and Ian Dury; early Human League represented the rise of electro pop music.

From punk itself two bands emerged from the smoking wreckage to sustain and further their musical quests. One of them was The Clash, the other was The Jam, and the contrast between the two was quite marked.

The Clash was a London band and much older than their rivals. Through their music, lyrics, and image, they espoused a worldly viewpoint and a strong, classical rock 'n' roll image. The Clash sang about Sandinista and Spain, Grandmaster Flash and Chairman Mao. Their music touched on many bases—rockabilly and hip hop, reggae and punk—and they spent a lot of their time in the studio. In two years alone, they released a double album, *London Calling*, then a triple album, *Sandinista!*. Controversy dogged their every step until they self-imploded.

In contrast, The Jam found their metier within the suburbs of Britain. With their third album, *All Mod Cons*, the band's leader, Paul Weller, started examining life in Smalltown Britain. In doing so, the band reached out to many who had felt disenfranchised from punk's London base, and at the same time hit upon a lyrical and musical direction that would make them incredibly successful.

Three of their singles entered the charts at number one. Advance orders for their albums were staggering, tours generated real hysteria. Weller's ability to sum up the banal nature of suburban life in poetic images and put his words to melodically charged music earned him the tag of youth spokesman, a title he did his utmost to shun.

The band's image was resolutely mod, with Weller sporting a classic sixties look—an effect he usually achieved by dressing in the style of one of his all-time heroes, Steve Marriott of The Small Faces. (When asked about The Jam once, Marriott quipped, "Cos I like them, I like me don't I?")

Unsurprisingly, one of The Jam's earliest influences was The Who. In 1979, the film of their concept album,

*Quadrophenia*, hit the cinemas. The album's story line was based around a young sixties mod called Jimmy, played by Phil Daniels. That the film was very unmodlike in its details and look didn't seem to deter the thousands of young kids who rushed to the stalls to see it.

The success of both this film and The Jam's growing stature led to a full-blown mod revival, with new bands such as Secret Affair, The Purple Hearts, and The Chords leading the way. Their presence and chart success suggested that the search for the Next Big Thing was over. Yet the mod revival only lasted a year and in truth was massively overshadowed by the movement known as 2-Tone.

If the mod revival had looked towards sixties pop and soul for inspiration, the 2-Tone bands differed by promoting Jamaica's greatest musical export, ska music. Dressing in a rude boy style of tonic suits and porkpie hats, bands such as The Specials, Madness, The Beat, and The Selecter quickly made a name for themselves with their energetic live shows and musical talent.

Punk played a big part in these bands' outlook. They ran their own record label—2-Tone—to maintain musical independence and at live shows often invited the audience up on stage. The bands all played different roles. Madness was 2-Tone's court jester, an aggregation of likable guys with a penchant for vital, catchy singles. The Specials was the movement's spiritual leader, a mix of the surreal and the street encapsulated by main songwriter Jerry Dammers' increasingly eccentric music and Terry Hall's deadpan vocals. The Beat was a party band and The Selecter reminded you of Britain's grim nature during some points of the late seventies.

Yet 2-Tone quickly ran into problems. In Jerry Dammers' memorable phrase, it soon became "an uncontrollable Frankenstein."

A lot of the trouble stemmed from the restrictive nature of the music. With The Specials' second album, *More Specials*, for example, Jerry Dammers attempted to move away from the ska sound and into more interesting, ambient-style material. This was not a well-received move among his fan club.

Another major headache was the resurgence of skinhead fashion and its relationship with the 2-Tone movement, especially Madness. Skinheads had last walked Britain's streets back in the mid-seventies. The soundtrack

of their lives was ska. Naturally, they were attracted straightaway to 2-Tone music.

Unfortunately, many of them lived by a violent agenda that saw many gigs ruined. Thanks to this proliferation of youth cults, tensions quickly arose. Fights between punks and mods and skinheads became a regular occurrence for many major cities and turned Britain's streets and its music venues into dangerous places. The cumulative effect on a band like The Specials was to push them away from live shows and into the studio where they remained for more than two years while they made their third album. By the time *In The Studio* was released, the 2-Tone movement was dead.

One band that should also be highlighted is Dexys Midnight Runners. Although they played on an early 2-Tone tour, their initial musical base was founded on obscure sixties soul music and Britain's unique northern soul cult. Led by the enigmatic and determined Kevin Rowland, Dexys put forward a gang image, dressing in similar clothes and propagating a clean-living philosophy that was directly anti–rock 'n' roll.

Their second single, "Geno," gave them their first number one while their debut album, *Searching for the Young Soul Rebels*, with its anxious lyrics and sublime, horn-driven music, remains a classic to this day. Dexys' greatest success would come in 1982 with their single, "Come on Eileen." But by then all of the above bands and movements and cults would have disappeared, decimated by the arrival of various clean-cut pop bands such as Wham! and Duran Duran.

These glossy pop stars with their overriding desire for fame and riches strongly reflected the conservative values of British Prime Minister Margaret Thatcher. The idea of the band as a force for political and social change would be ridiculed, and musical experimentation cast aside.

Music had just entered its first dark age.

Paolo Hewitt

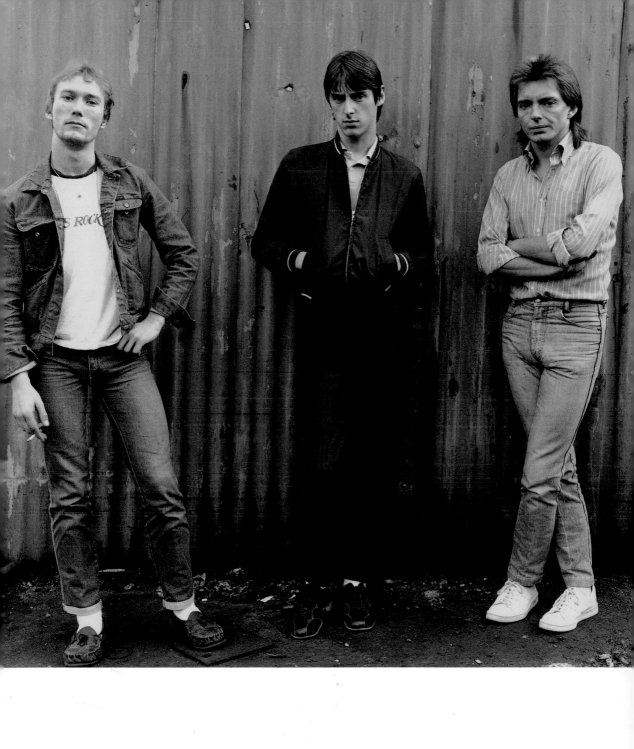

" I can still see these images from 1969 to 1970—when we were mini-skinheads—the top faces walking through Woking town center. The whole look. The sleek, stream-lined aesthetic qualities of a scooter. You could say it's a fashion statement, but I think it's more than that: the work-ing class love of clothes, looking good, rising above your station. I don't think it'll ever die. It's really in our British fiber....These clothes, my haircut, reflect my attitude and the music I listen to, and they say, 'I'm an individual.'

Paul Weller, The Jam, *Mojo*, 2004 "

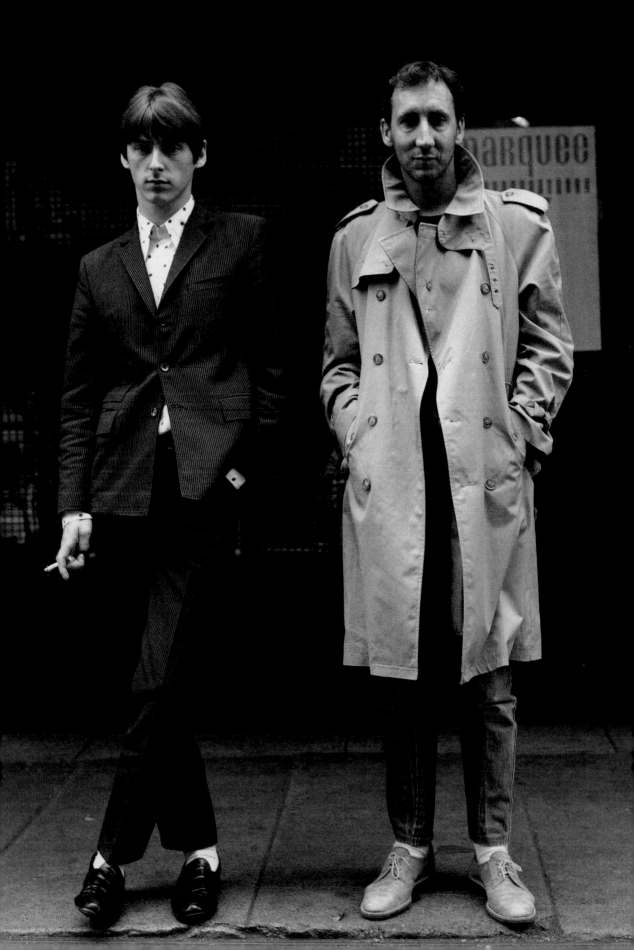

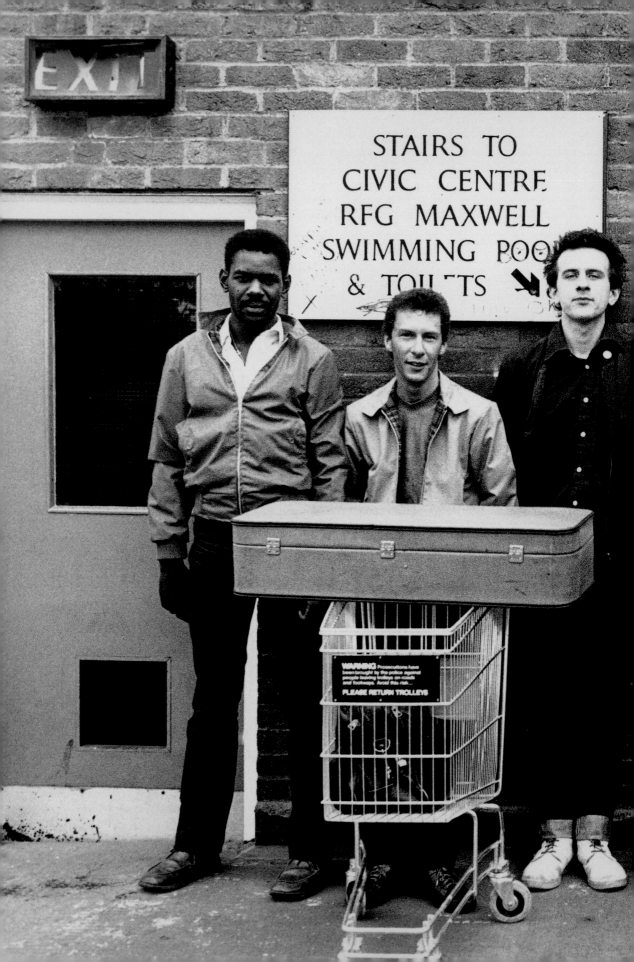

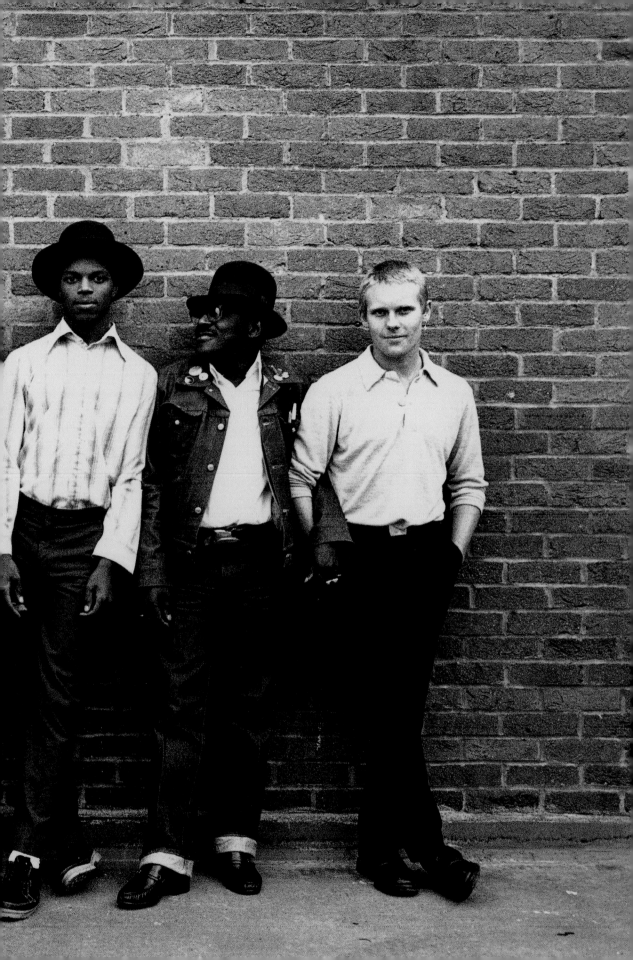

 Fuck art—let's dance."

<div align="right">Madness</div>

"There were a lot of kids from the King's Road squats who used to come to our gigs. They were out of their heads on tuinol and other downers. At three in the morning you'd see loads of kids on the street out of their heads. Most of the people we knew down there were skins, they used to get busted all the time."

Carl Smyth aka Chas Smash, Madness, *The Face*, 1982

"The 2-Tone attitude was similar to punk. It was good not to see any hidden mystique in music or to believe you had to be really good to play it. I hate the attitude that there is something special about music or musicians. I think anyone should be able to get up and have a go at it. At the time the punk thing came along you'd think you had to be playing for five years before you could make a record.

<div align="right">Mike Barson, Madness 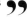</div>

 I saw The Specials twice and to this day they're still two of the best gigs I ever saw. At the Rainbow in 1980 they closed the evening with a new song called 'Ghost Town.' I think it was the first time they played it live and the crowd was mesmerized. It's the last time I remember a number one single showing the ugly face of England in all it's bleak, miserable glory....I miss them...."

<div align="right">Phill Jupitus, BBC 6 Music</div>

"It's the stuff that turns legs to rubber and plays pinball with your brain."

<div align="right">Mark Ellen, *NME*, 1979</div>

"I enjoy playing the piano on my own and going into a trance. An extension of that would be jamming with musicians then taking it to an audience.

"What was good about [2-Tone] was the way bands helped each other and influenced each other. There was a camaraderie and it wasn't too competitive.

"When we began The Specials there was a certain punk sensibility, but the music and the clothes were completely different....Using those old elements like ska to form something new...you've got to go back to go forward.

<div align="right">Jerry Dammers, The Specials 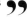</div>

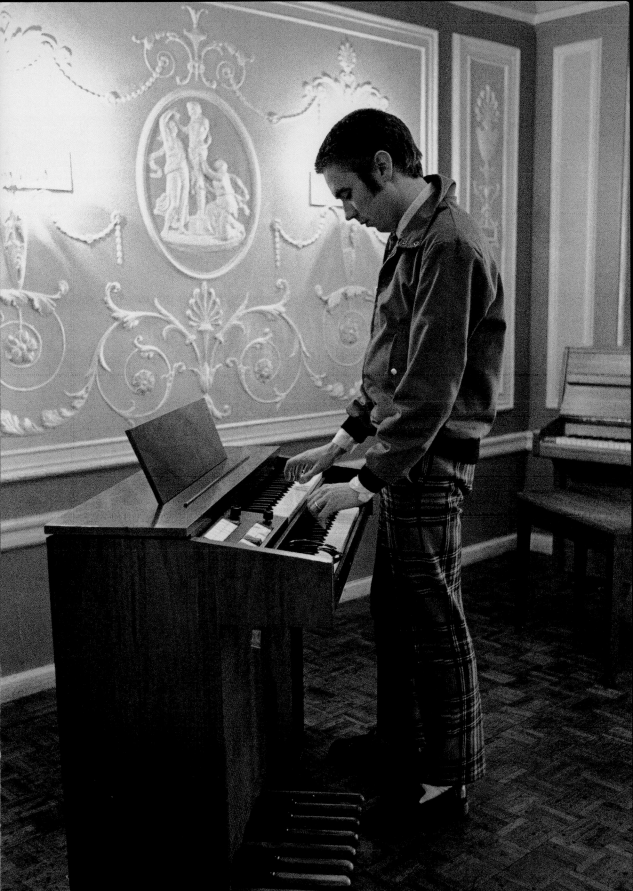

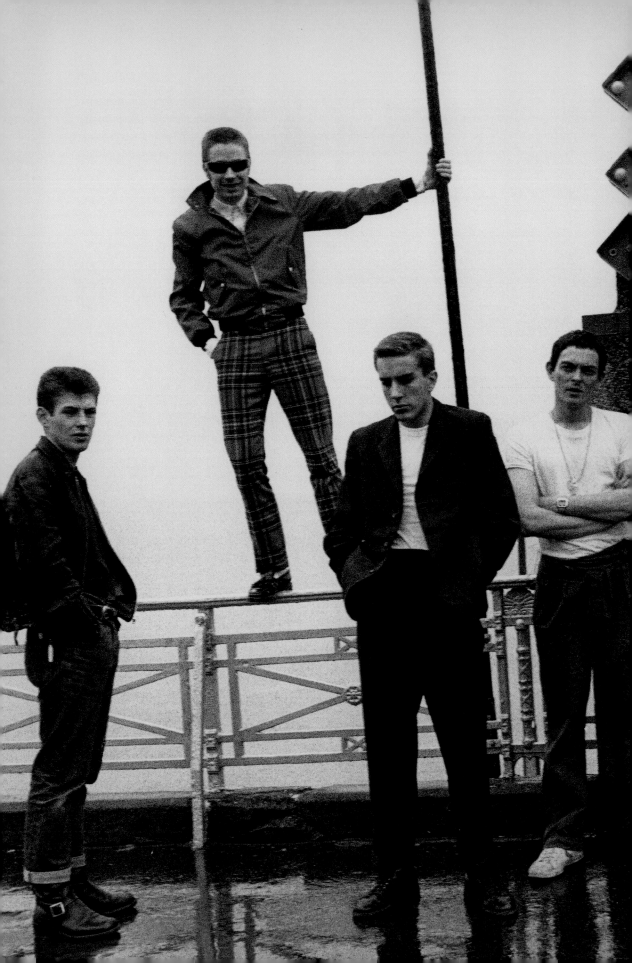

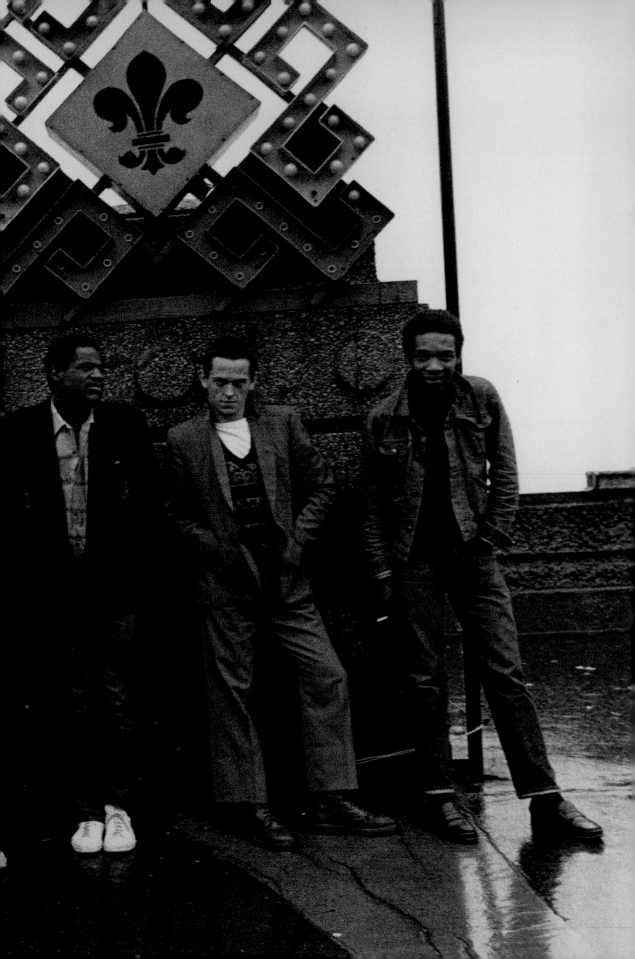

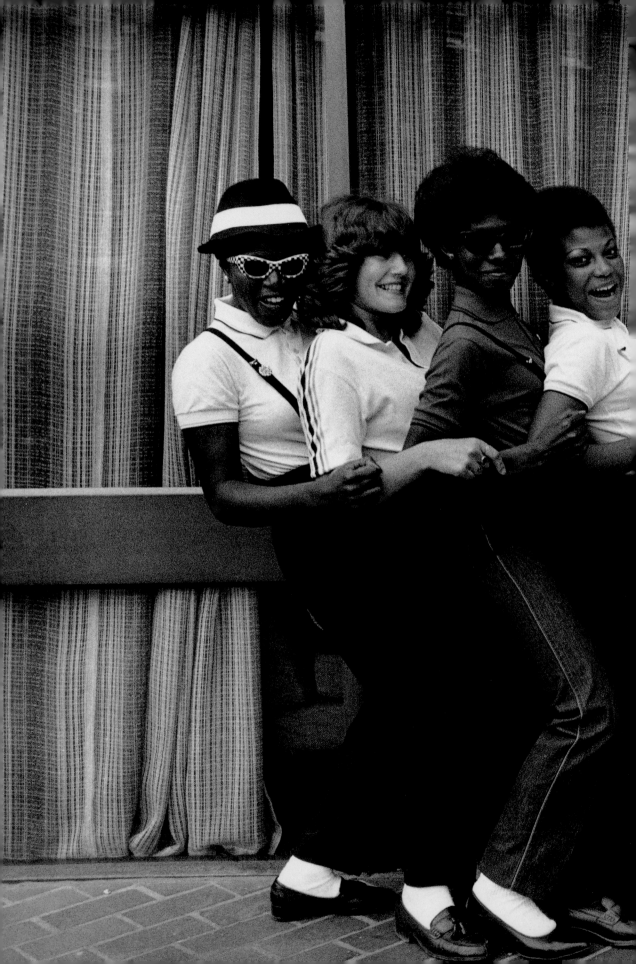

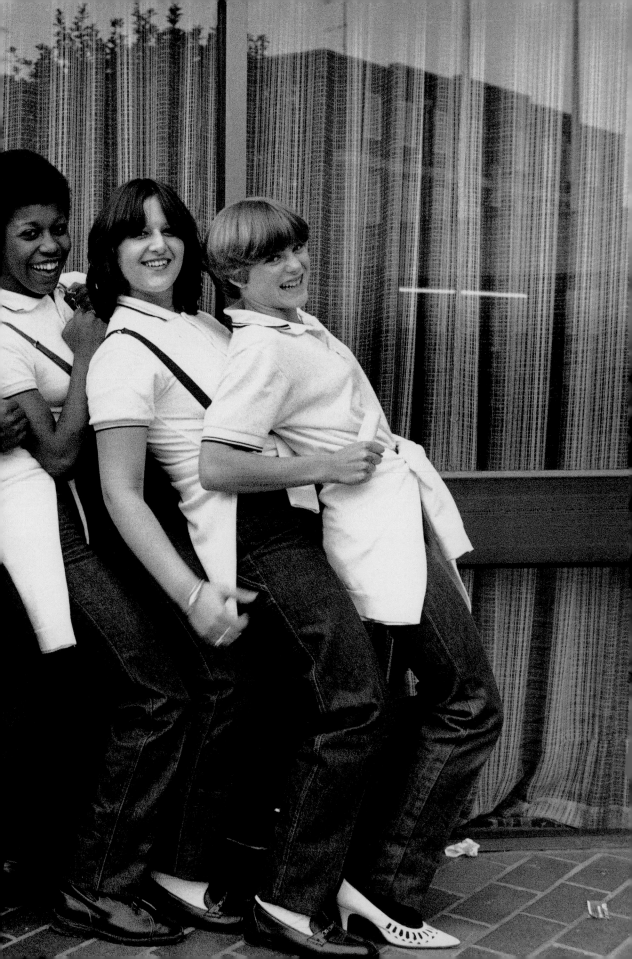

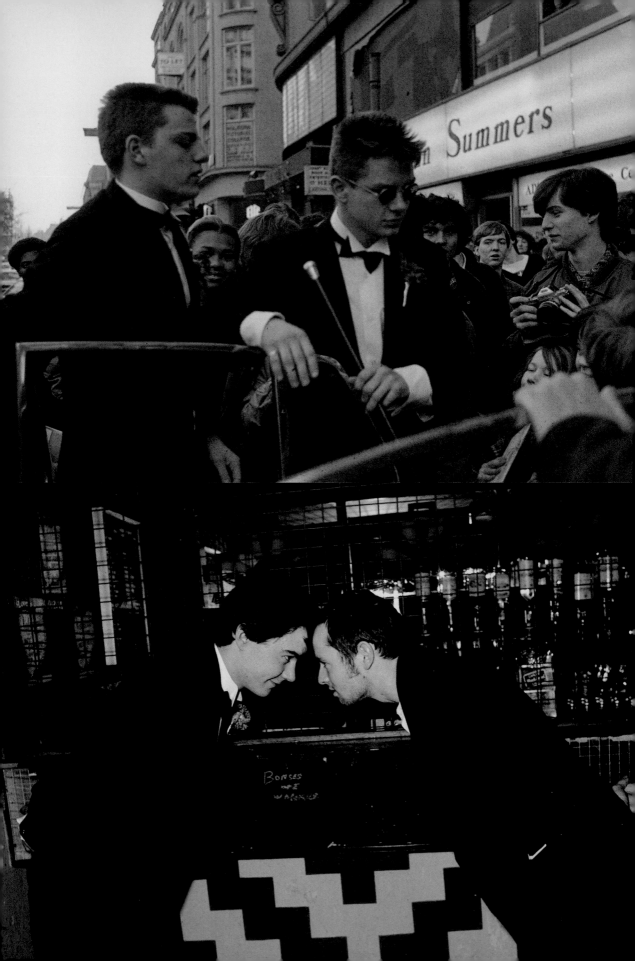

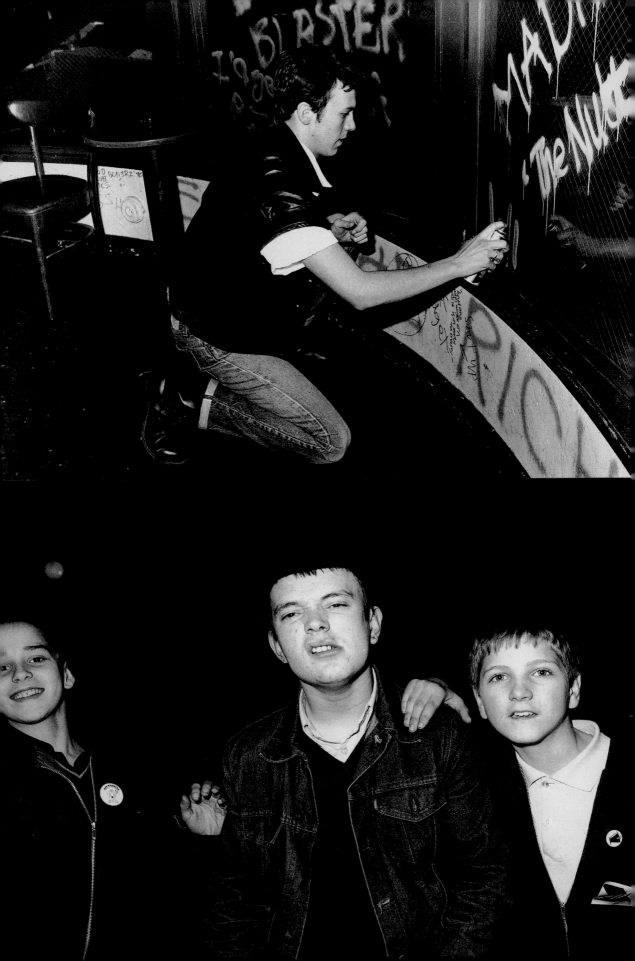

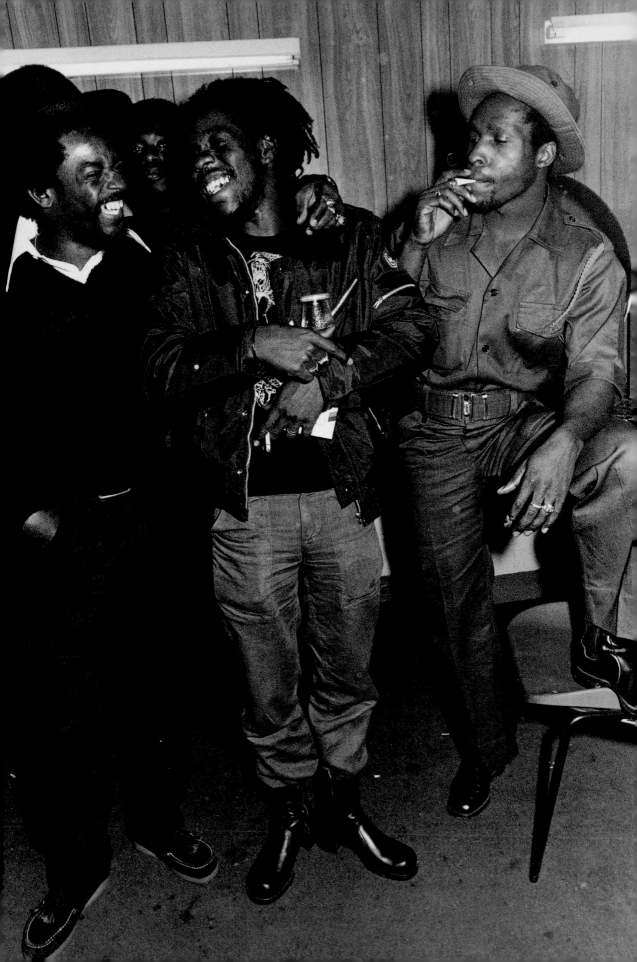

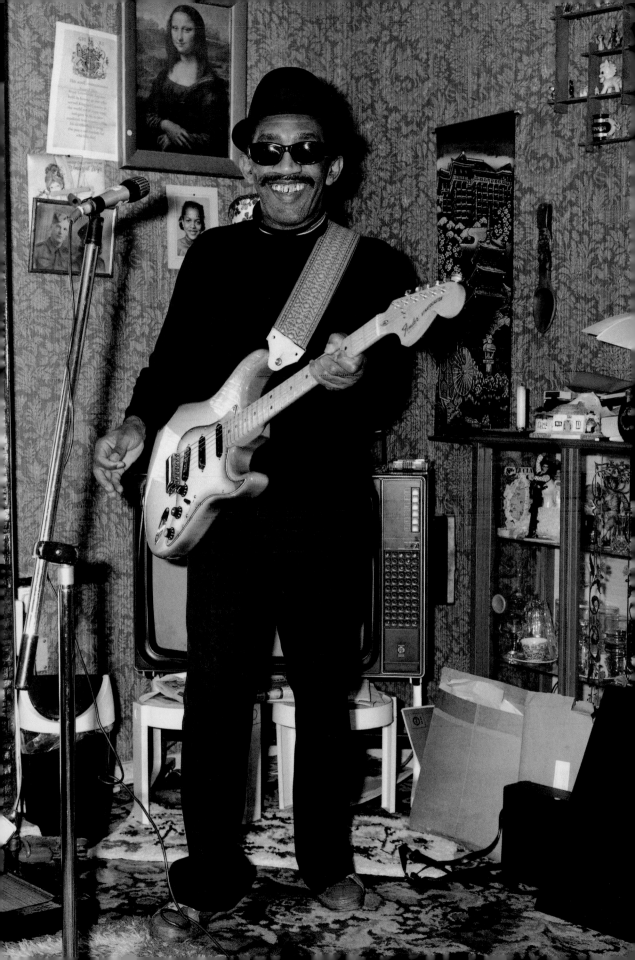

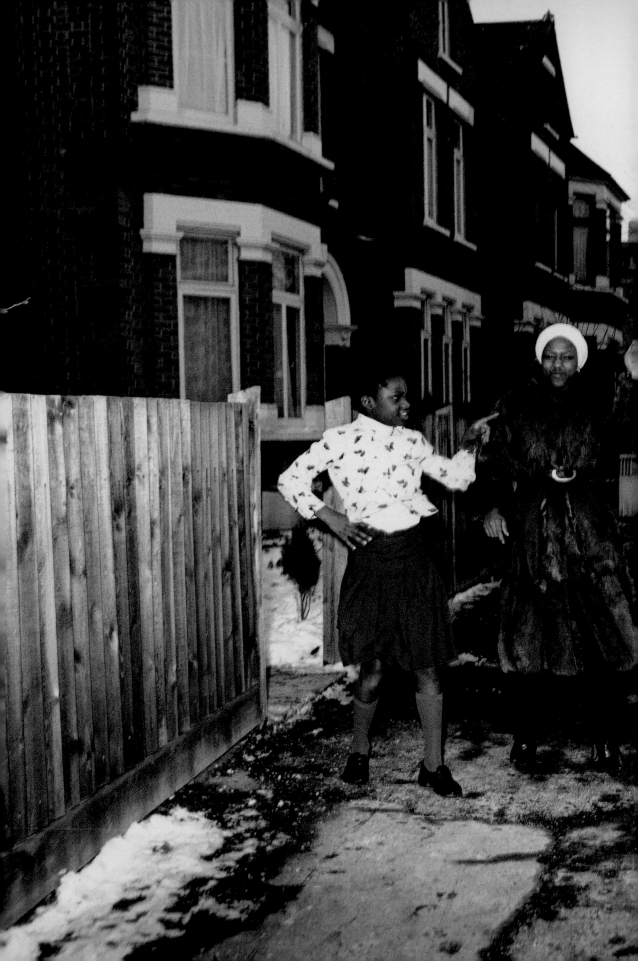

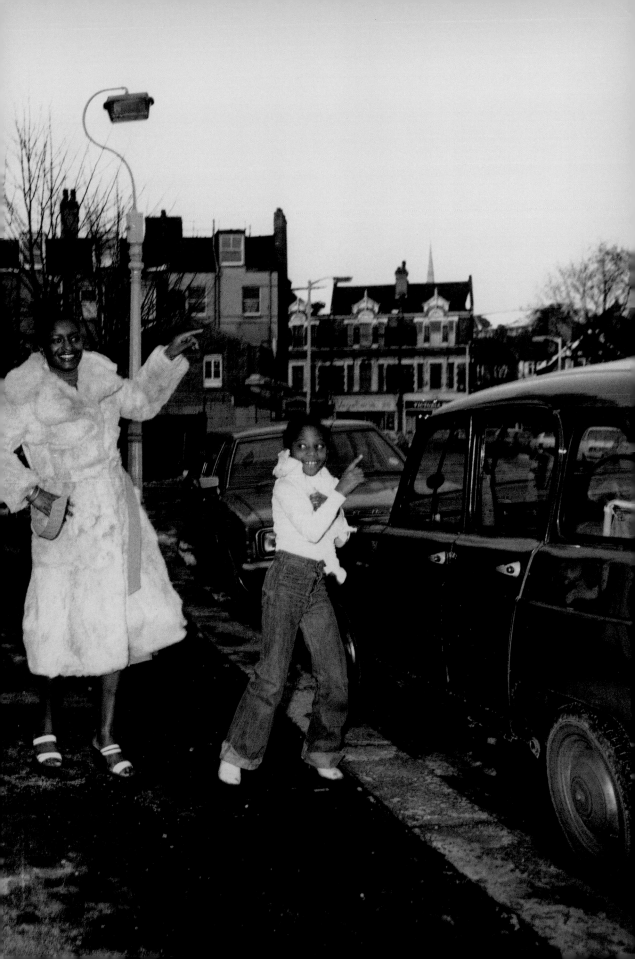

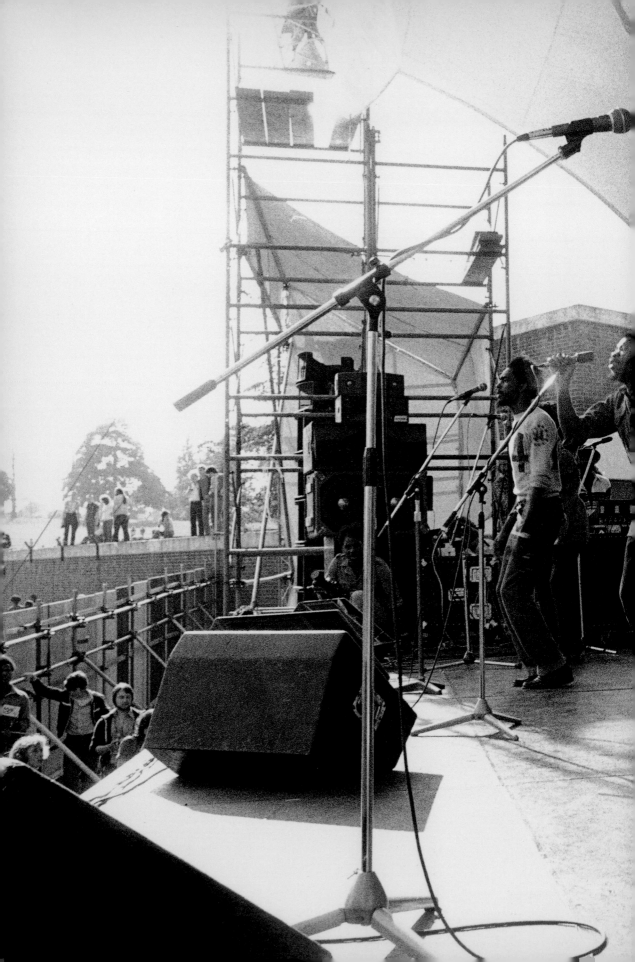

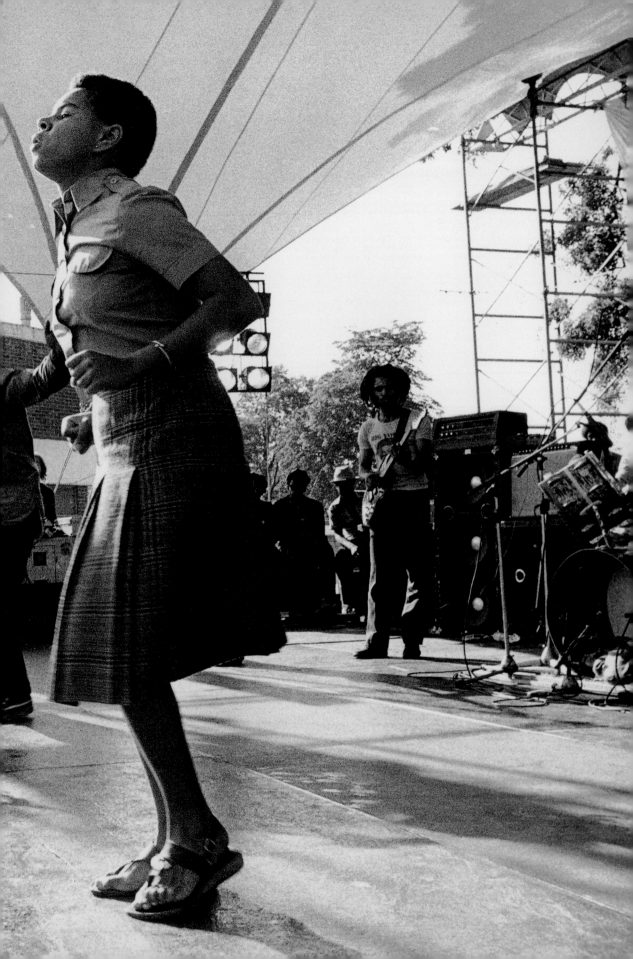

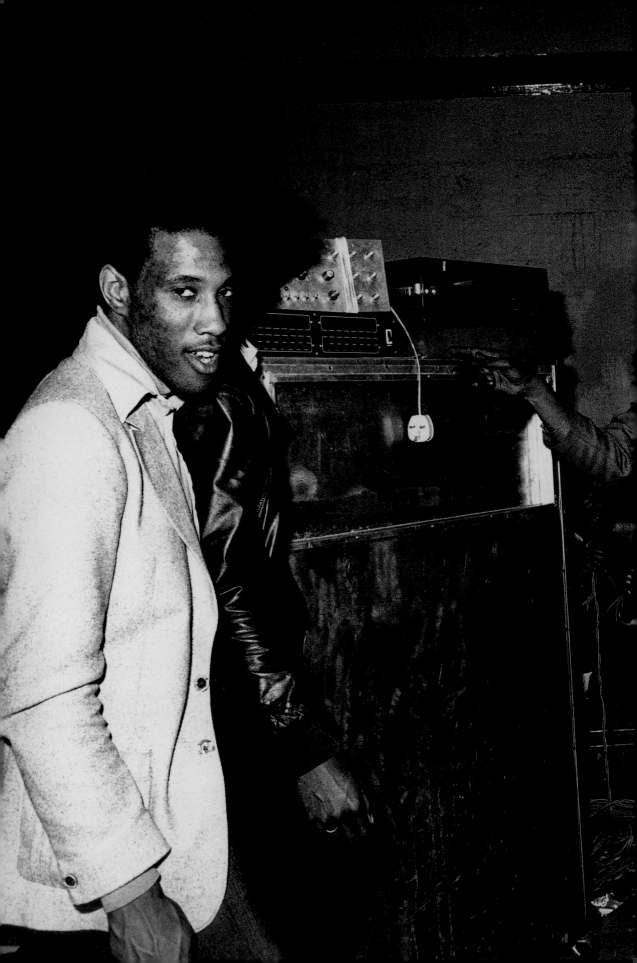

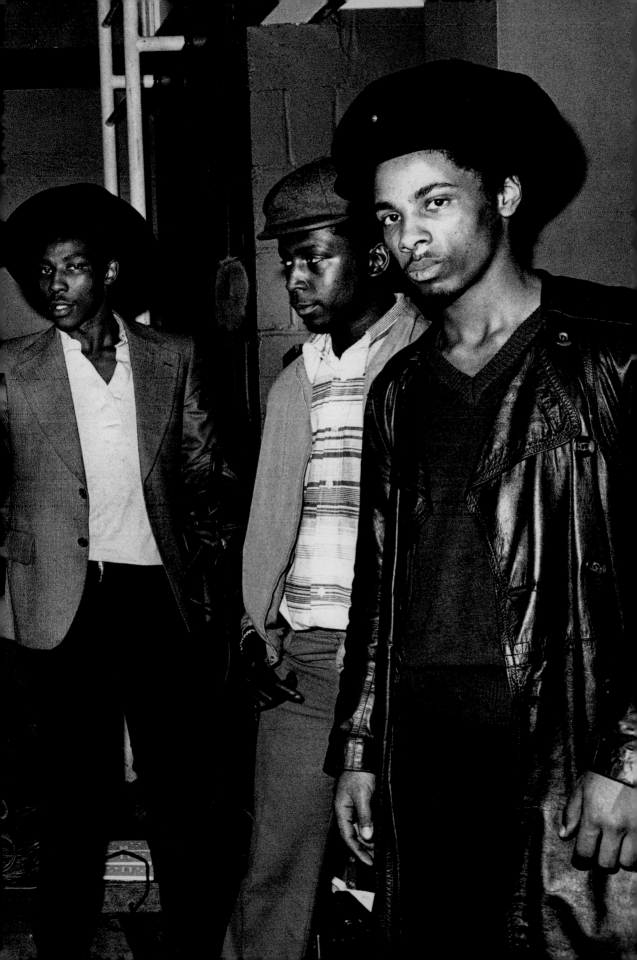

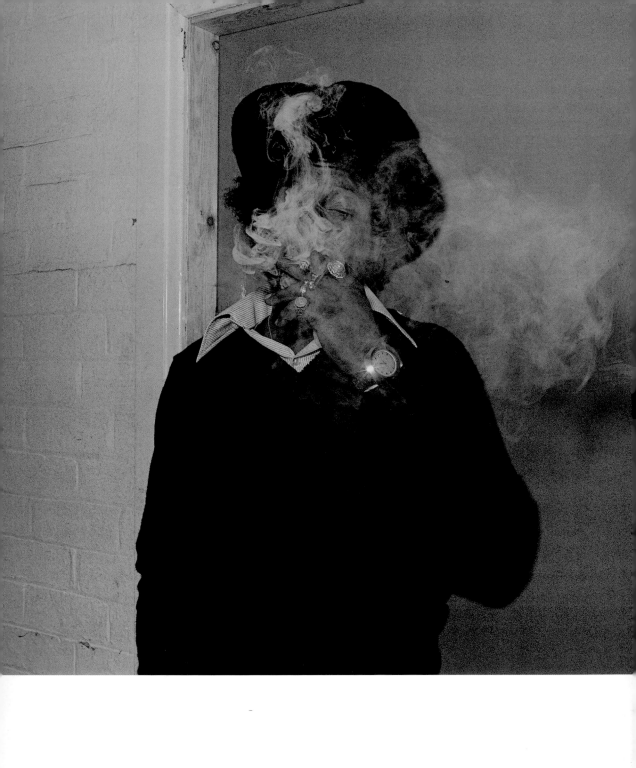

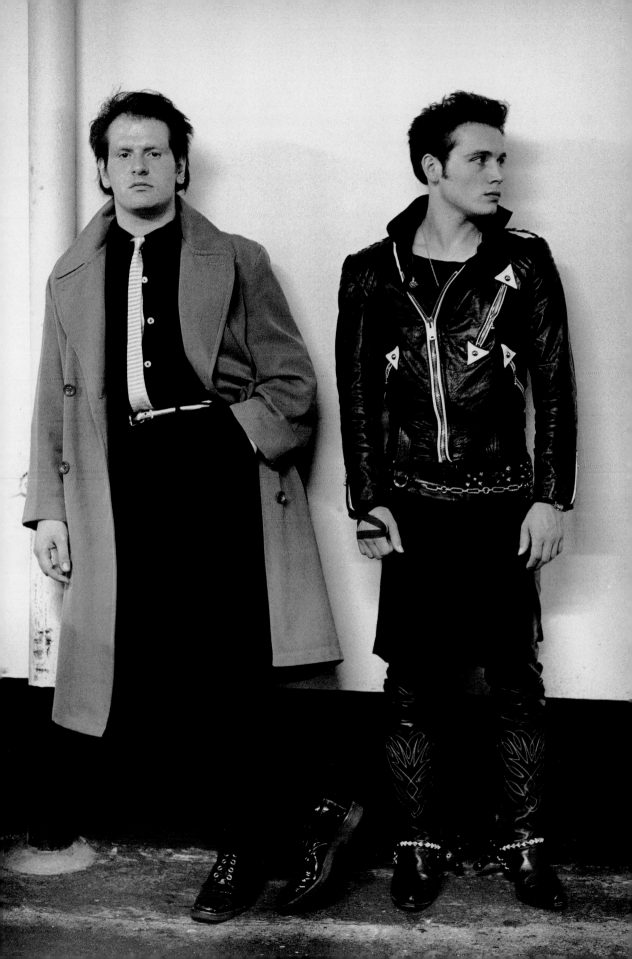

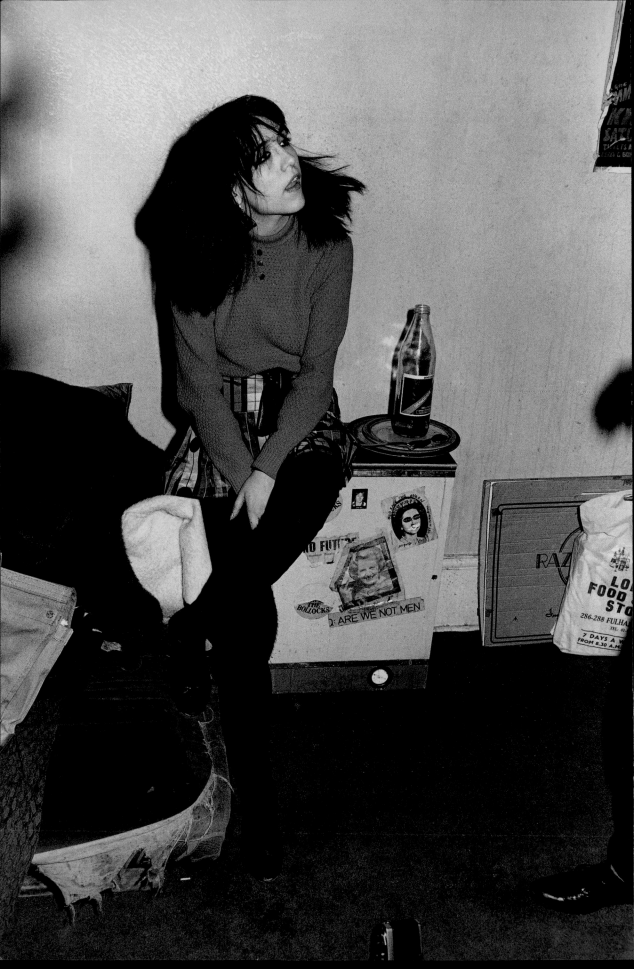

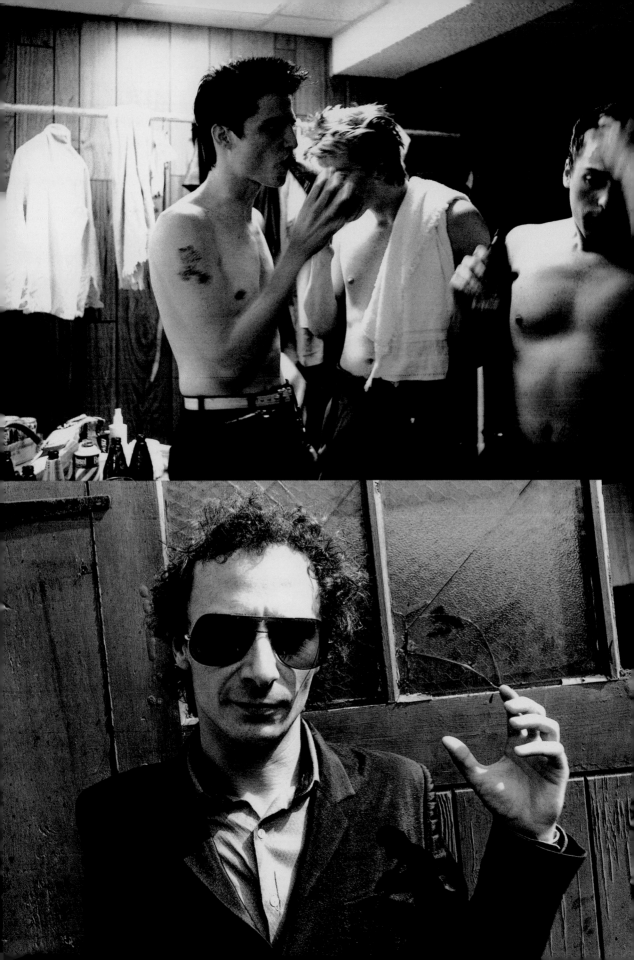

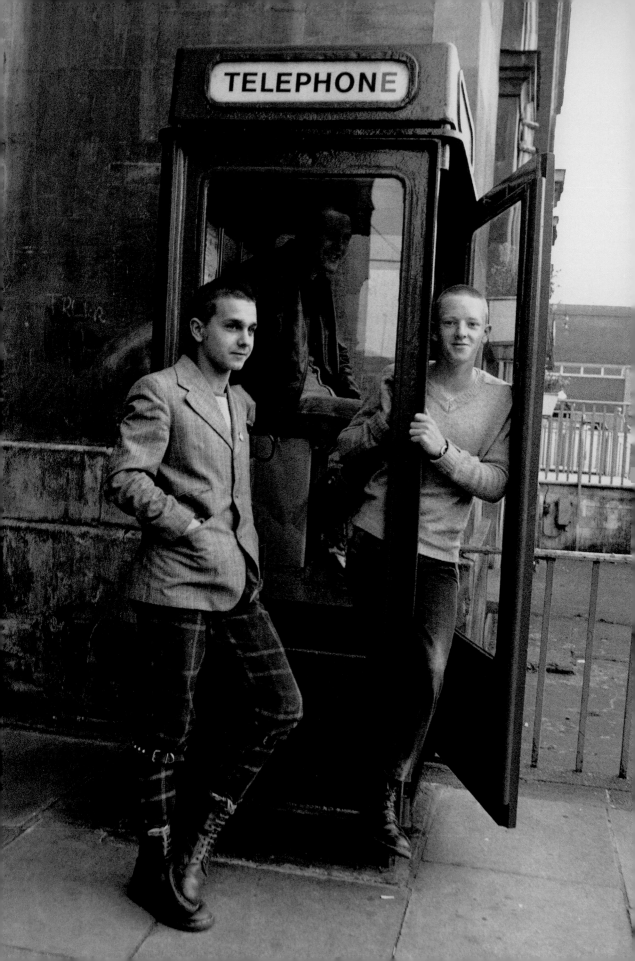

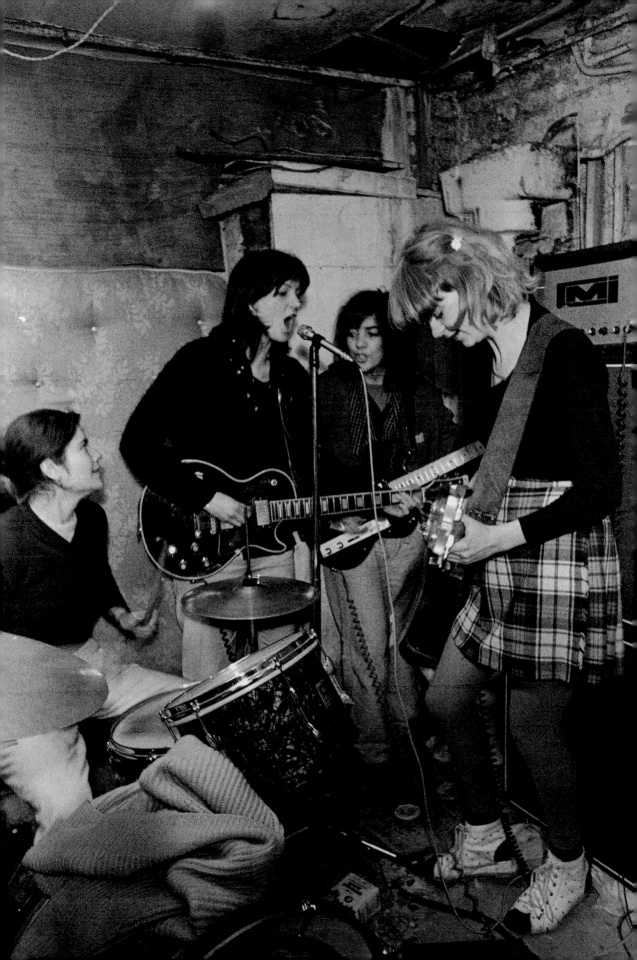

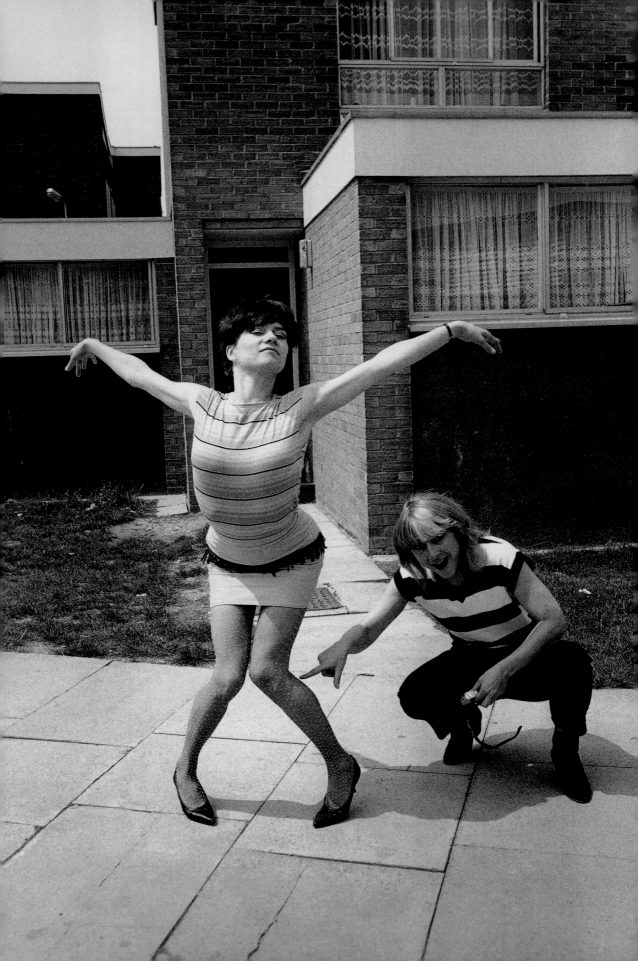

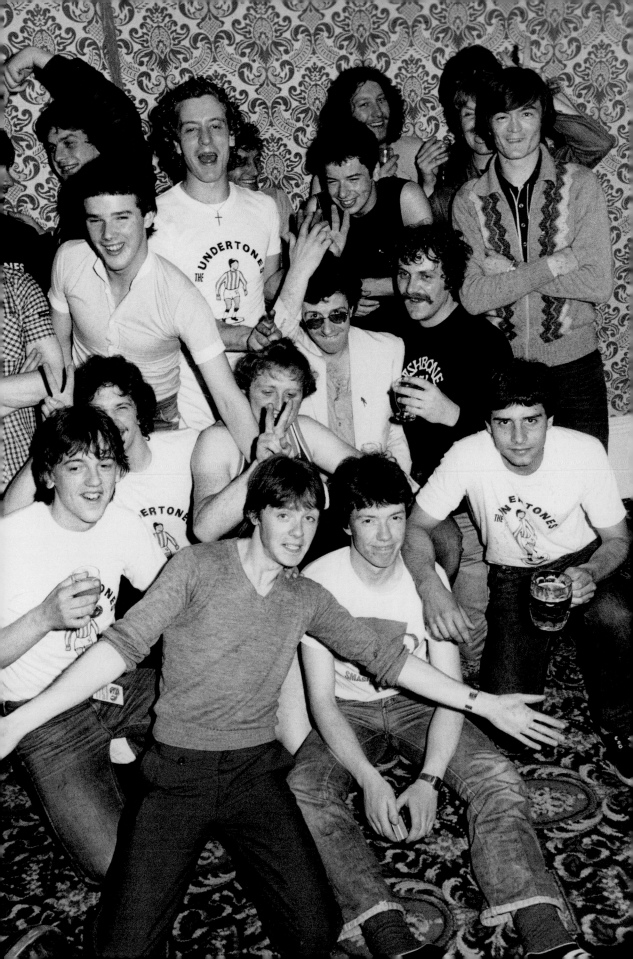

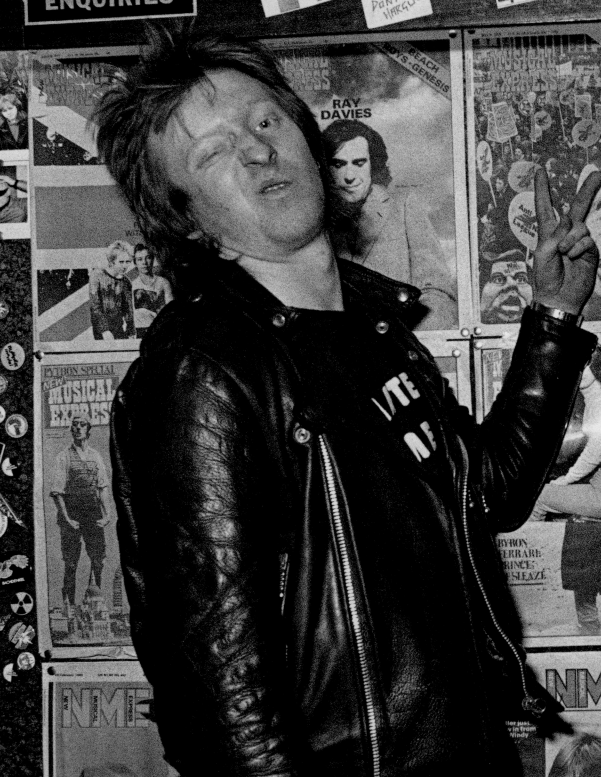

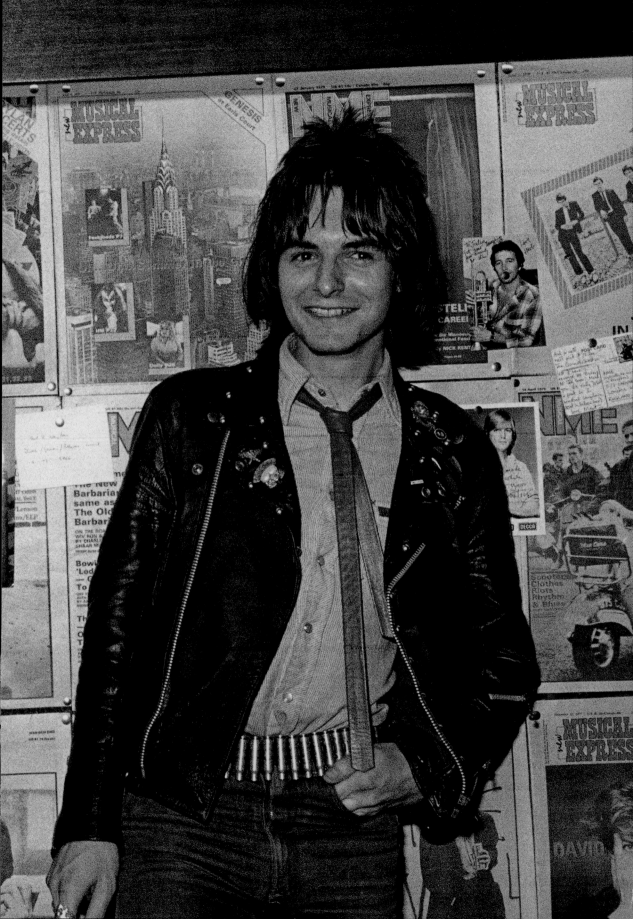

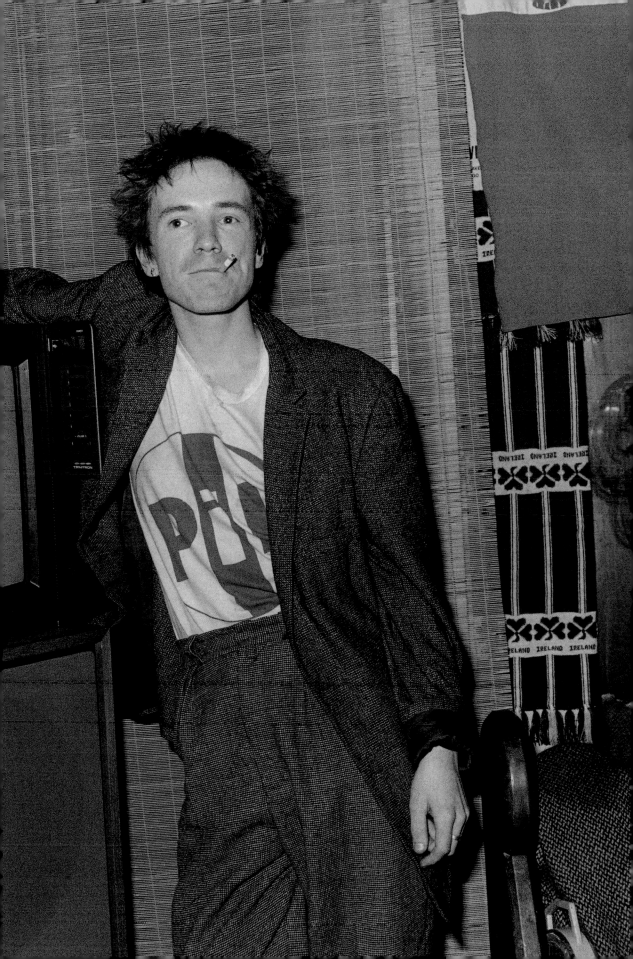

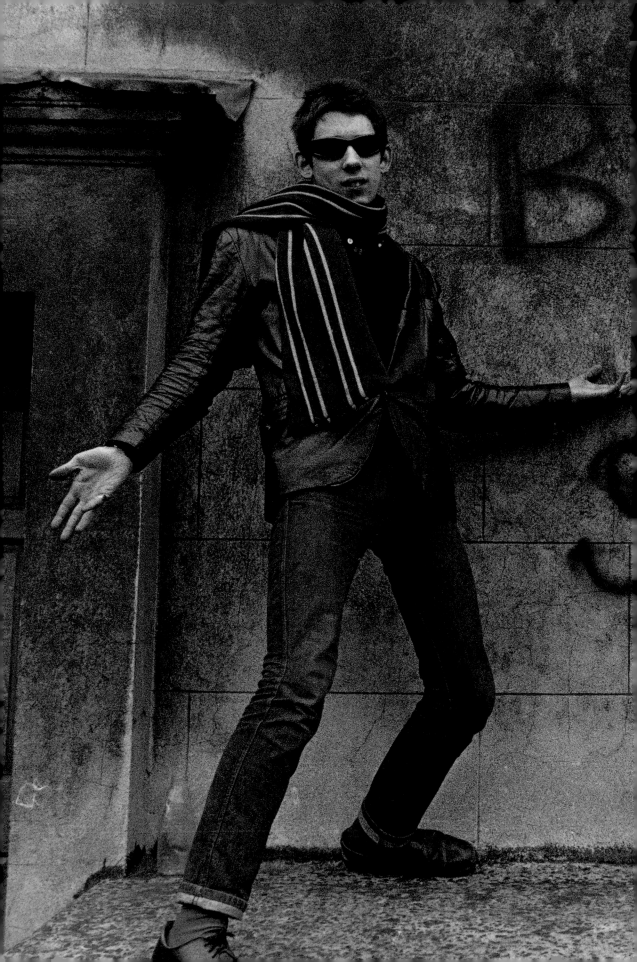

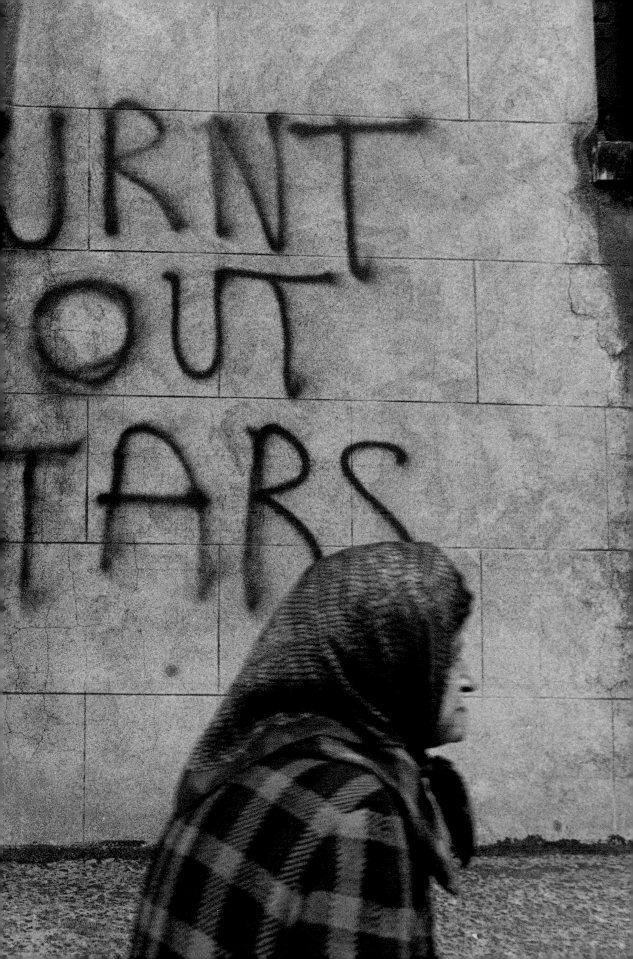

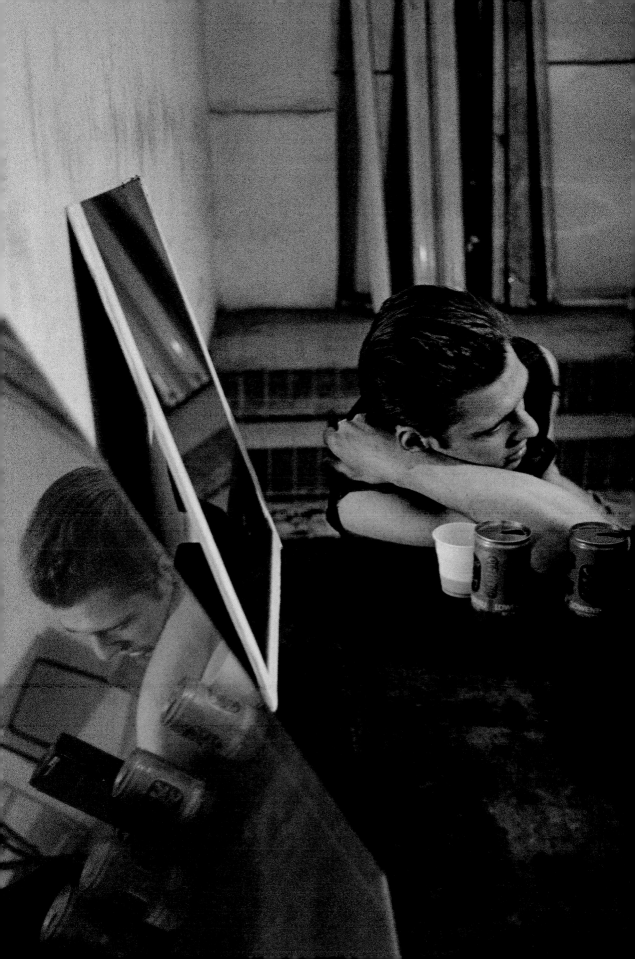

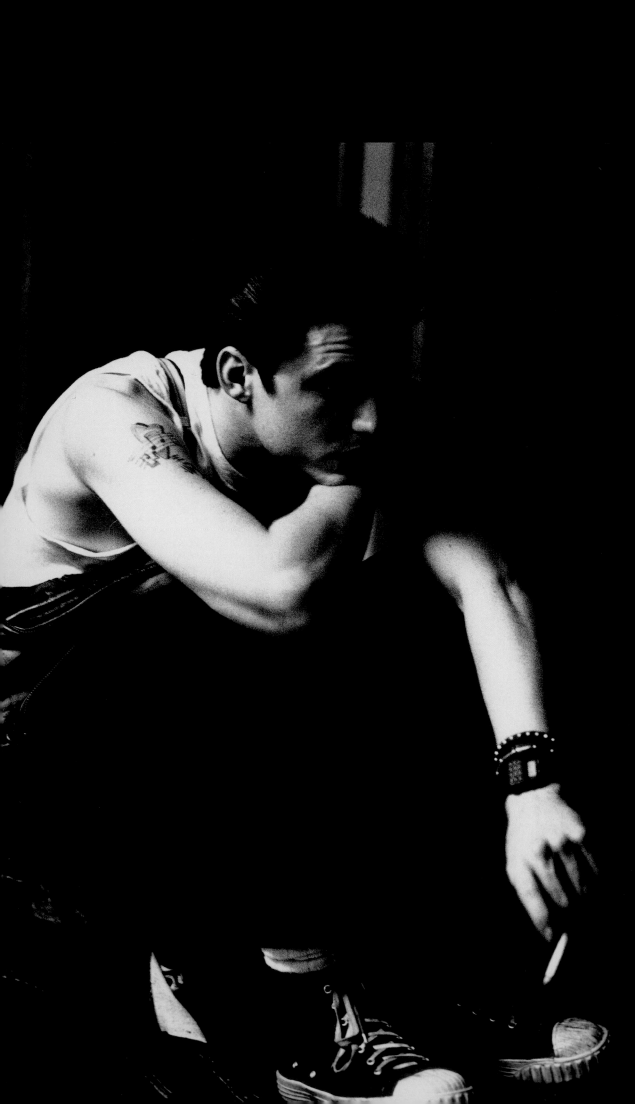

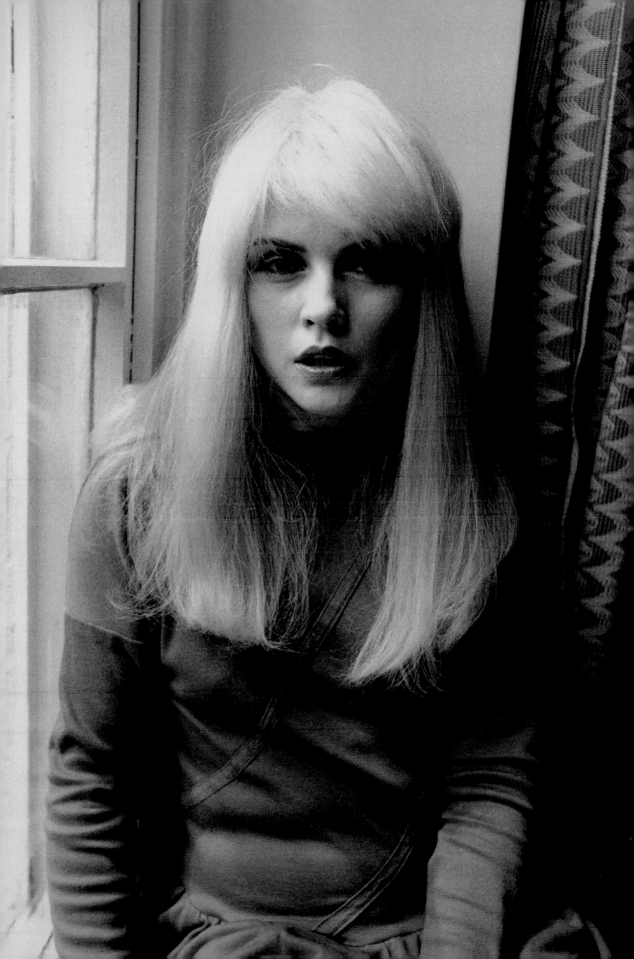

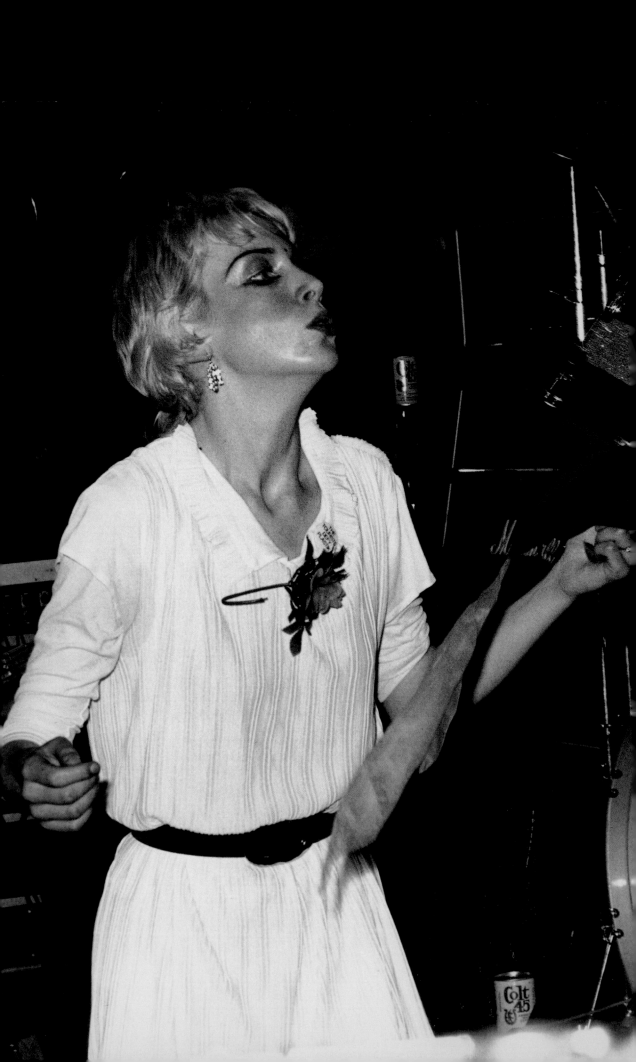

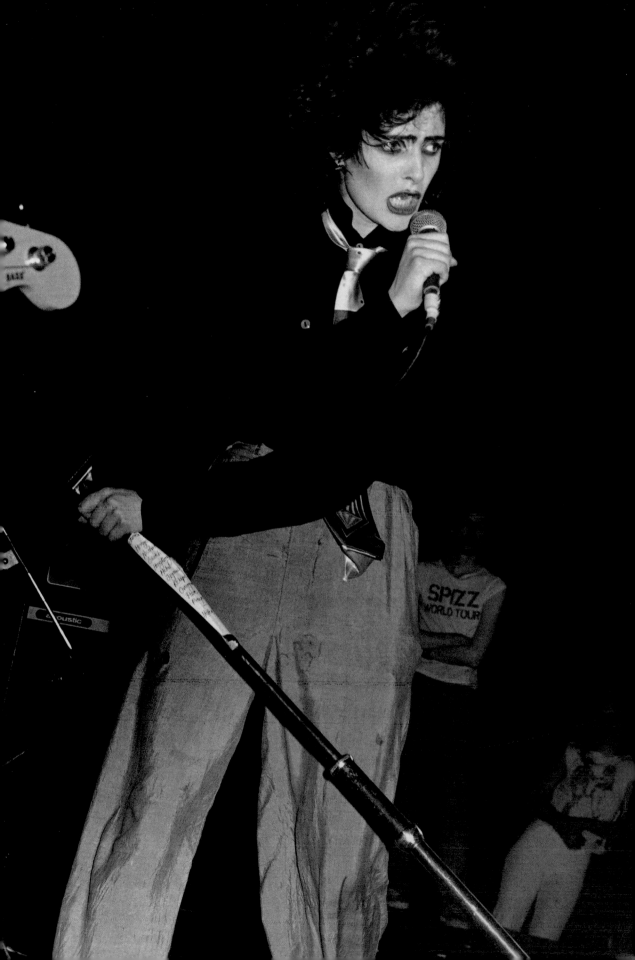

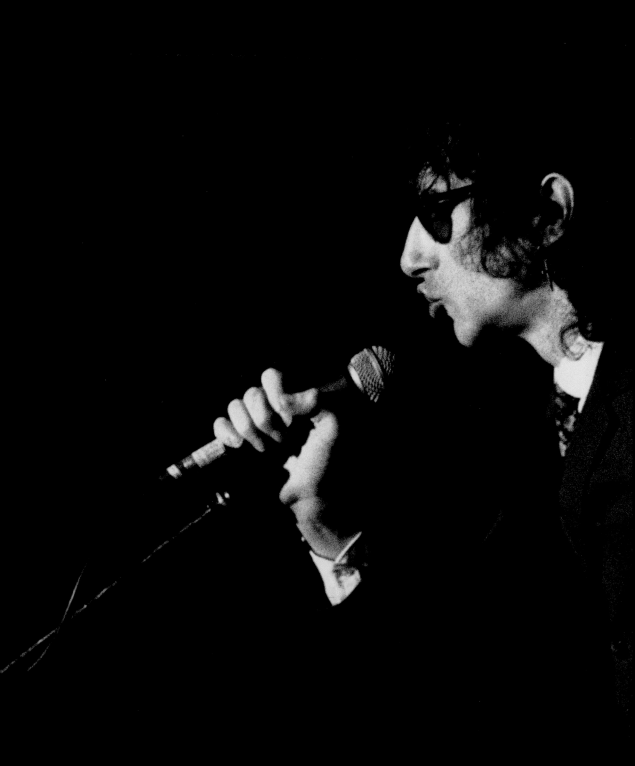

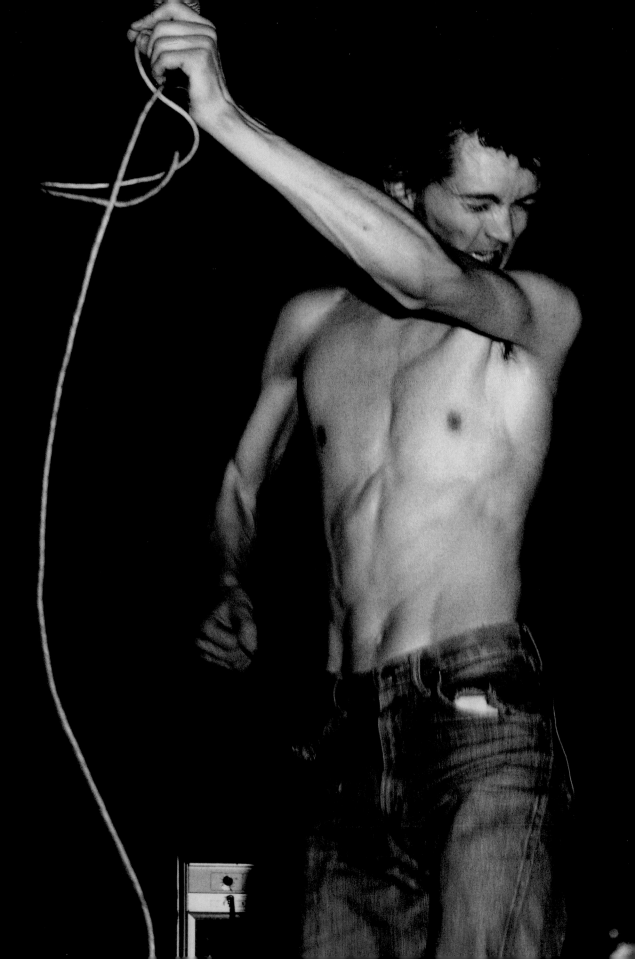

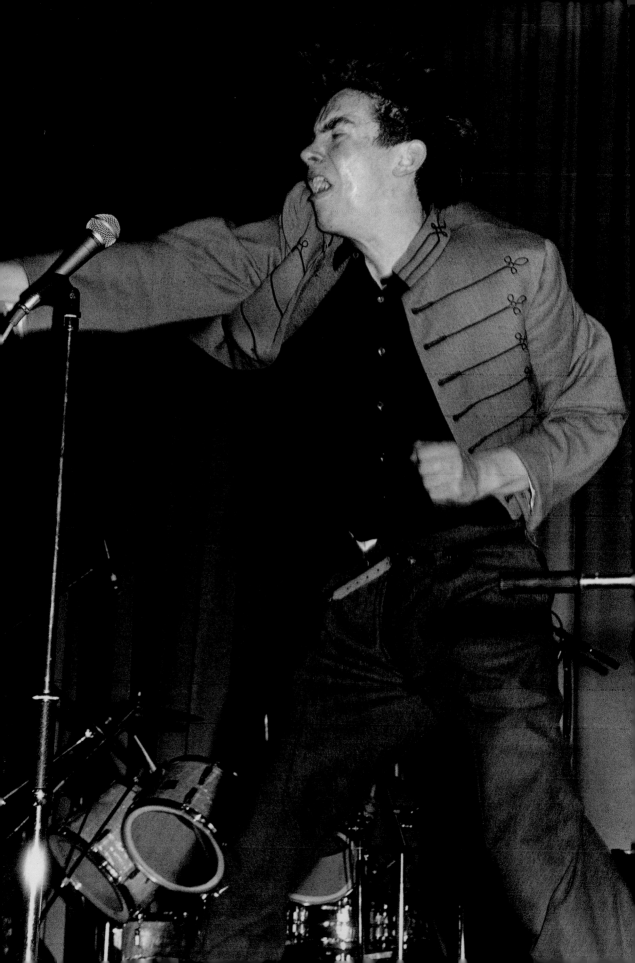

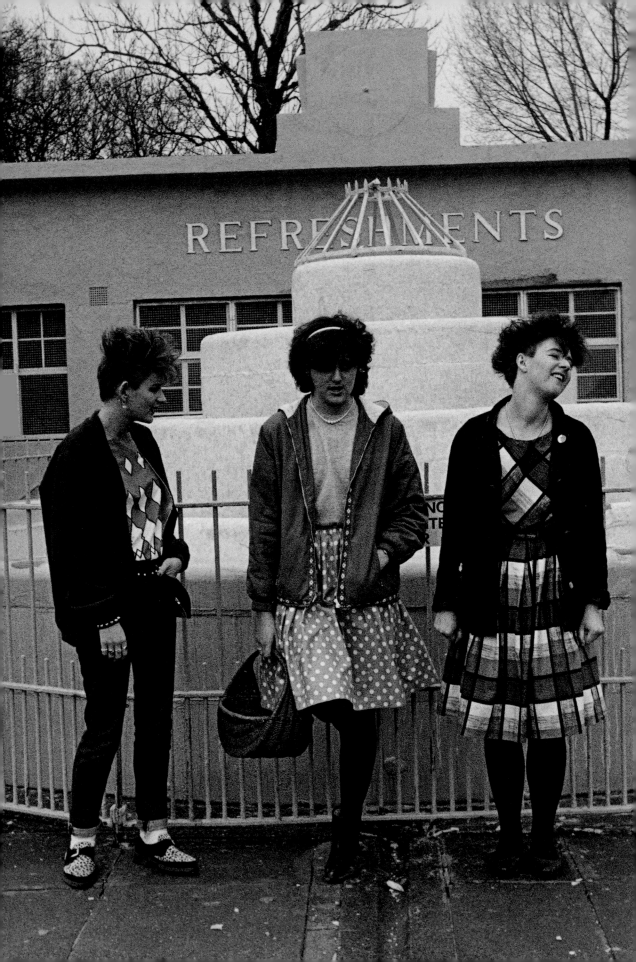

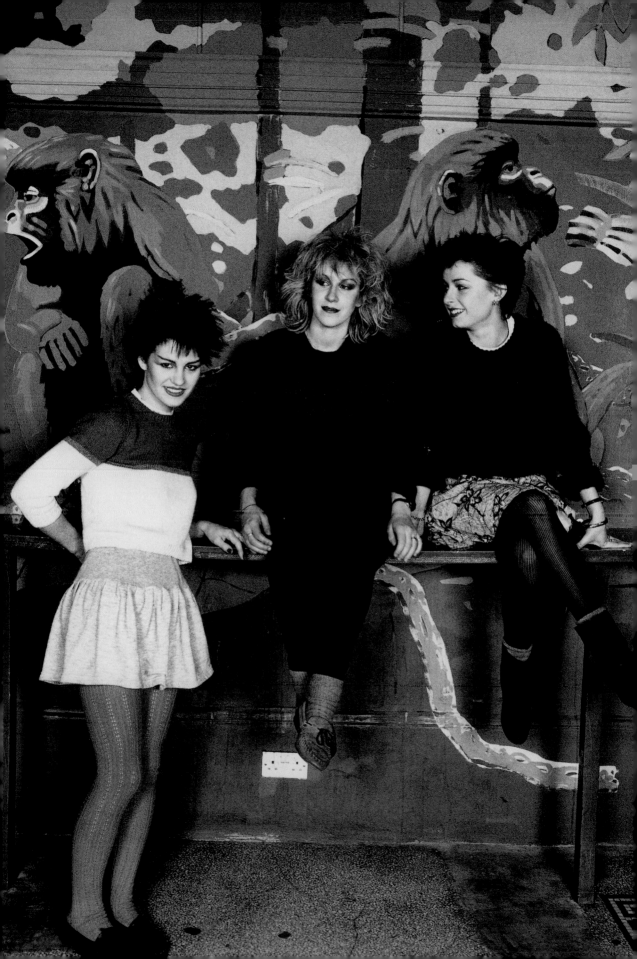

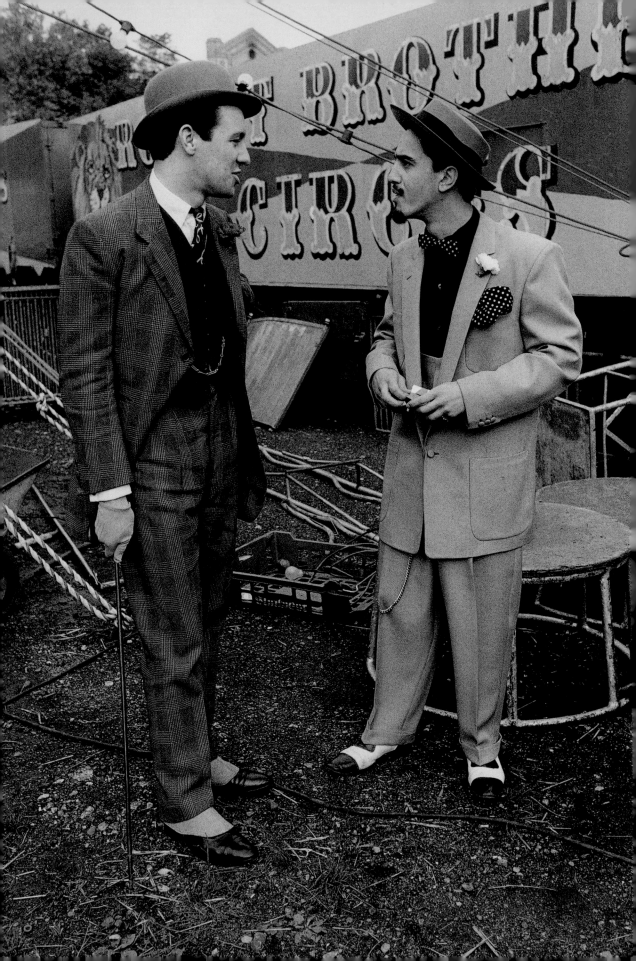

" We were young and we were flash. We thought we were the best things on God's earth. You have to at that age!

"I was wearing a pink zoot suit and talking in a cockney accent—a working class expression of flash. We were about style and we got slagged off in all the middle class press. We were working class blokes walking round in suits, and by that time punk was about middle class blokes going around in torn-up clothes. Bob the Tailor in the East End made our suits. He used to be in the merchant navy and had tattoos, a real cockney bloke. He knew how to cut a suit in the American way and understood our desire for extreme cutting and tailoring, long jackets and really high trousers, without making it look ridiculous.

"There were youth cults happening all over the place. After '83 the youth culture thing stopped and hip hop took over the world.

Christos Tolera, Blue Rondo a la Turk "

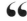

" I think what some people don't realize is that a lot of normal people are buying our single, like housewives. So when people say to me, 'Oh, you're only getting somewhere on your look,' it's shit. Up until about two weeks ago, most people thought I was a girl."

Boy George, *The Face*, 1982

"They were referred to as Blitz Kids, New Romantics, Glam Revivalists but what *The Face* magazine called 'the cult with no name' began way back in a Soho London venue called Billy's. Billy's wasn't a place for those who dressed up for the occasion but those who dressed as a way of life. A small incestuous group numbering no more than a couple of hundred kids in search of a lifestyle.

*The Face*, 1980 "

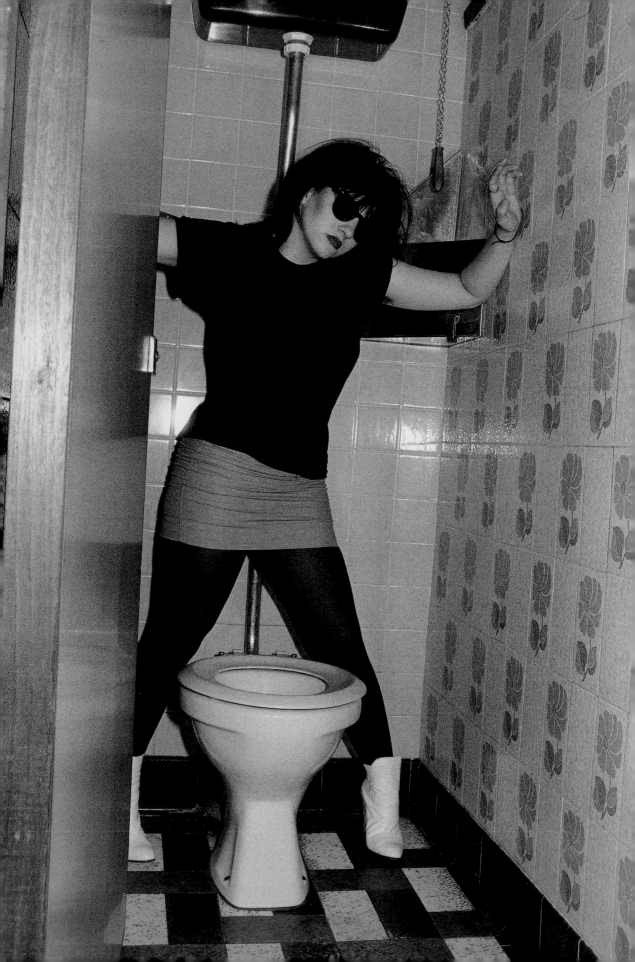

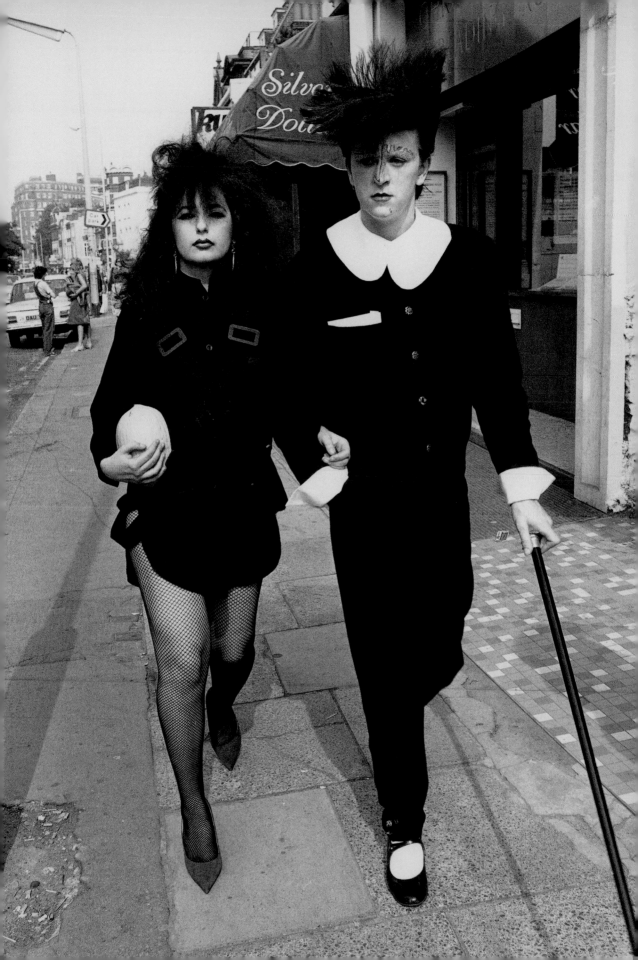

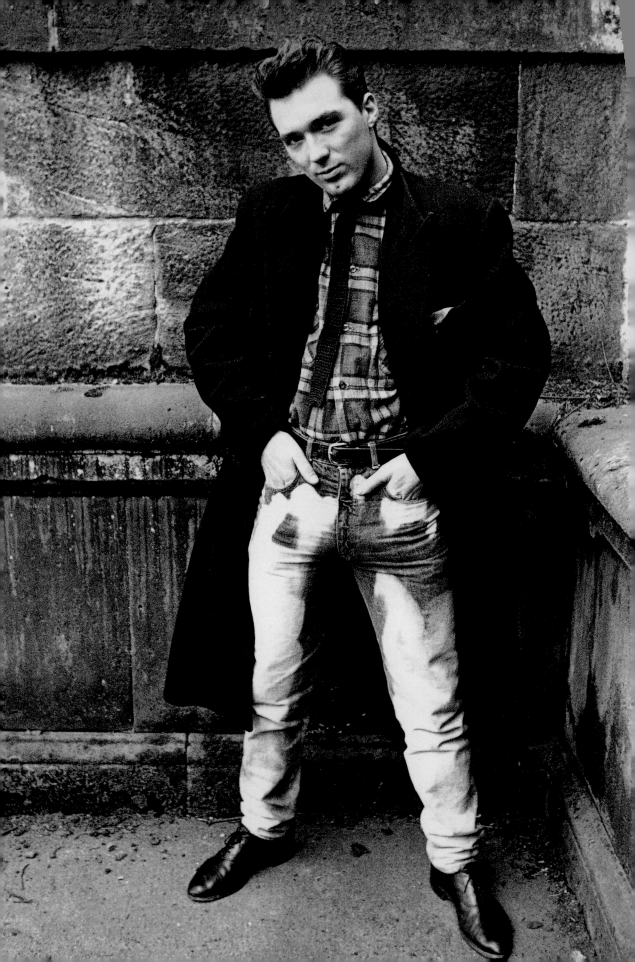

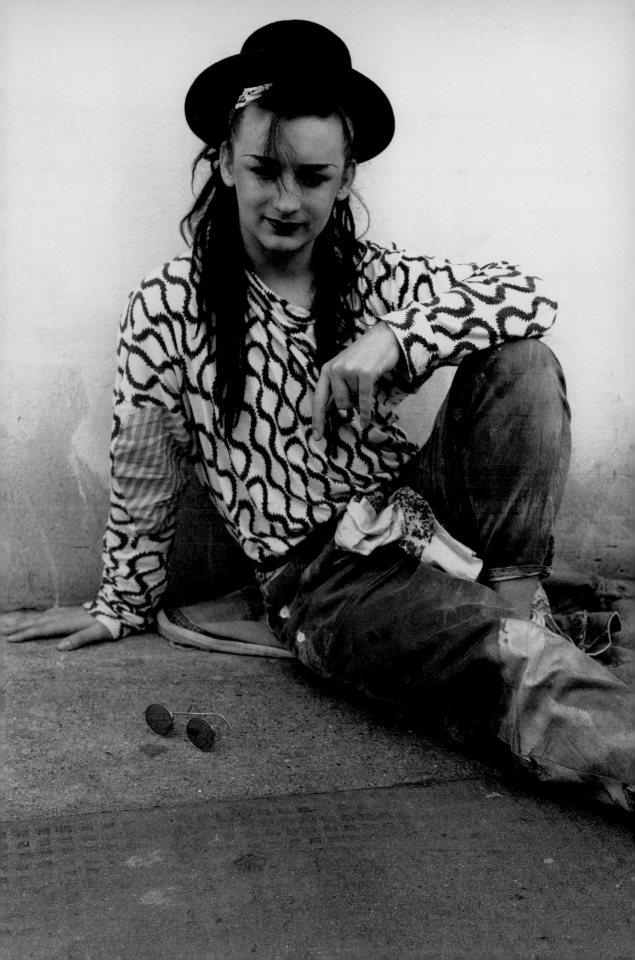

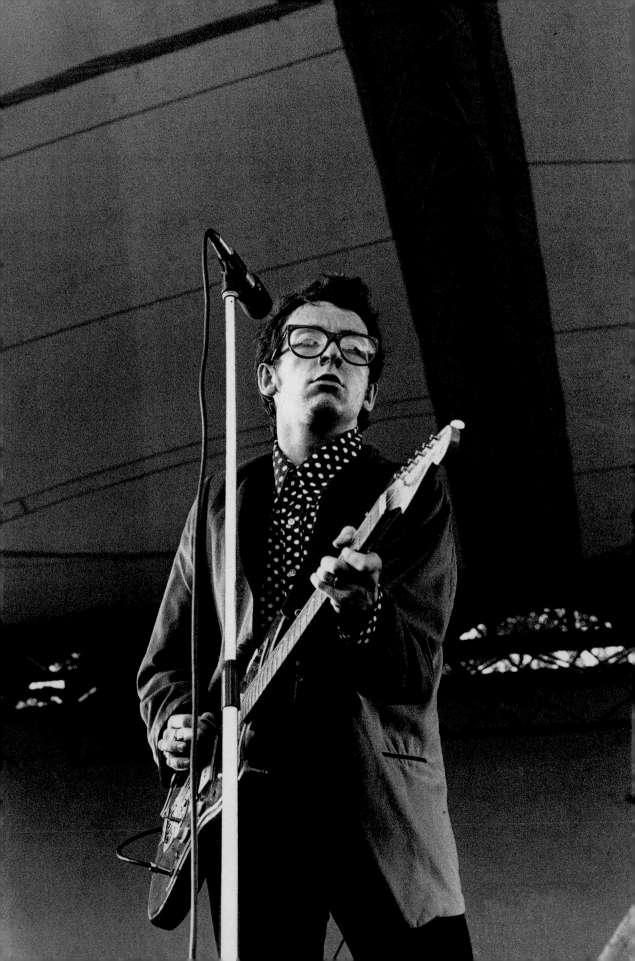

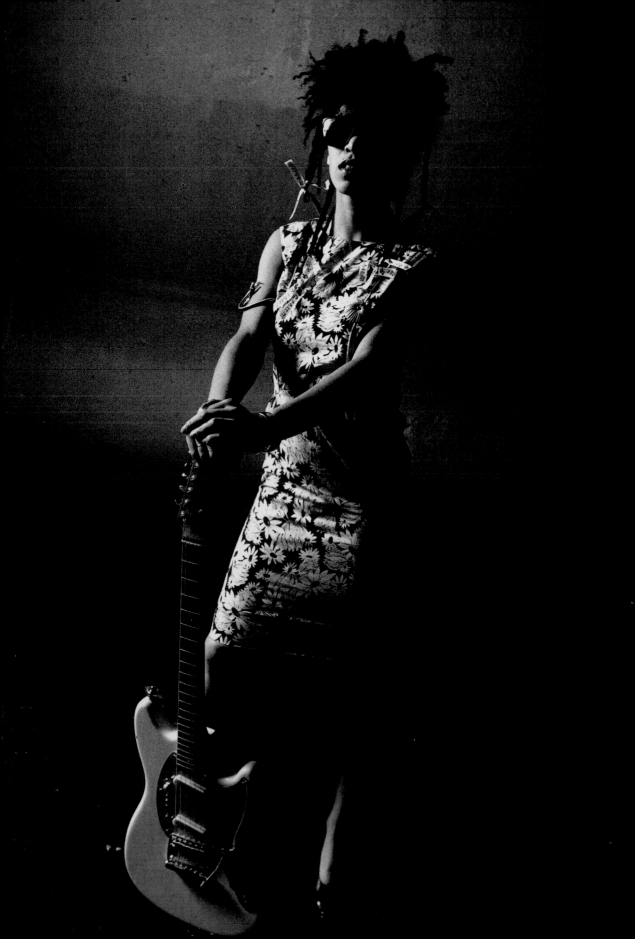

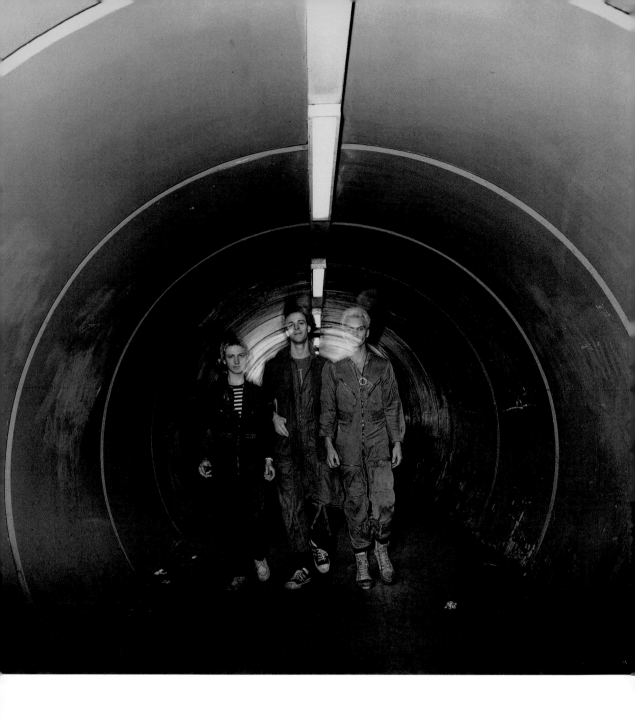

66 There's a very clear, very simple gestalt to The Police.
There are three blond heads and that's it. That sells. Once
you get beyond that, there are three fairly interesting adults
who actually speak coherently....I could see where the
power of punk energy lay, and so we welded it to reggae,
which was a much more sophisticated and seductive thing.
Because we were experienced musicians, we could do that.

Sting, The Police 99

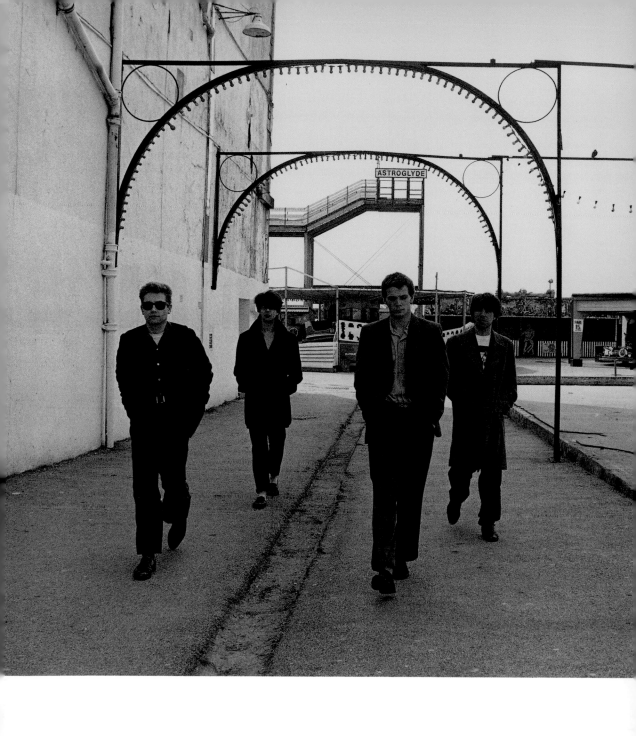

> "You don't write a song like 'God Save the Queen' because
> you hate the English race. You do it because you love them."
> Johnny Rotten, The Sex Pistols

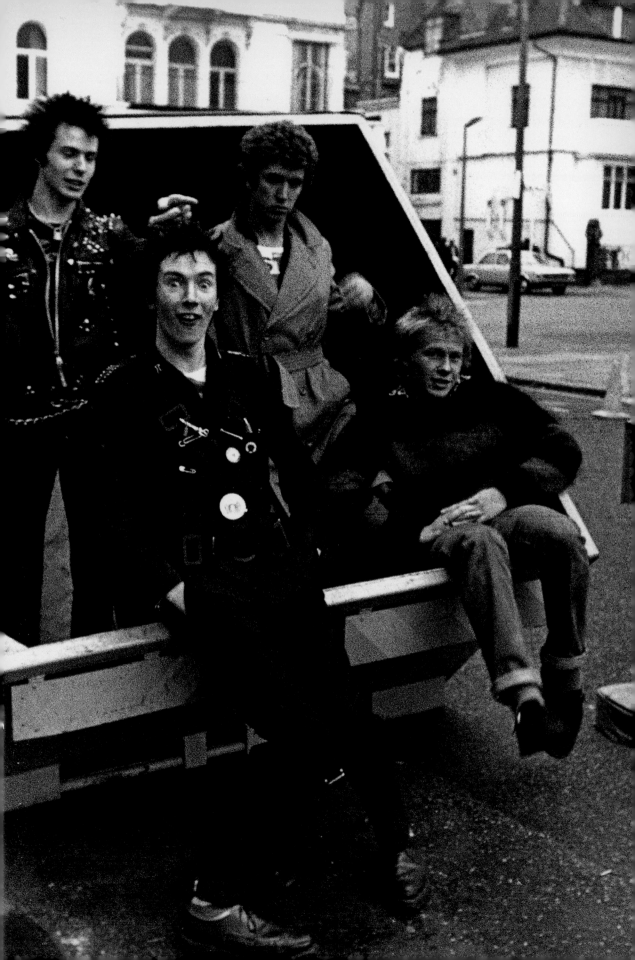

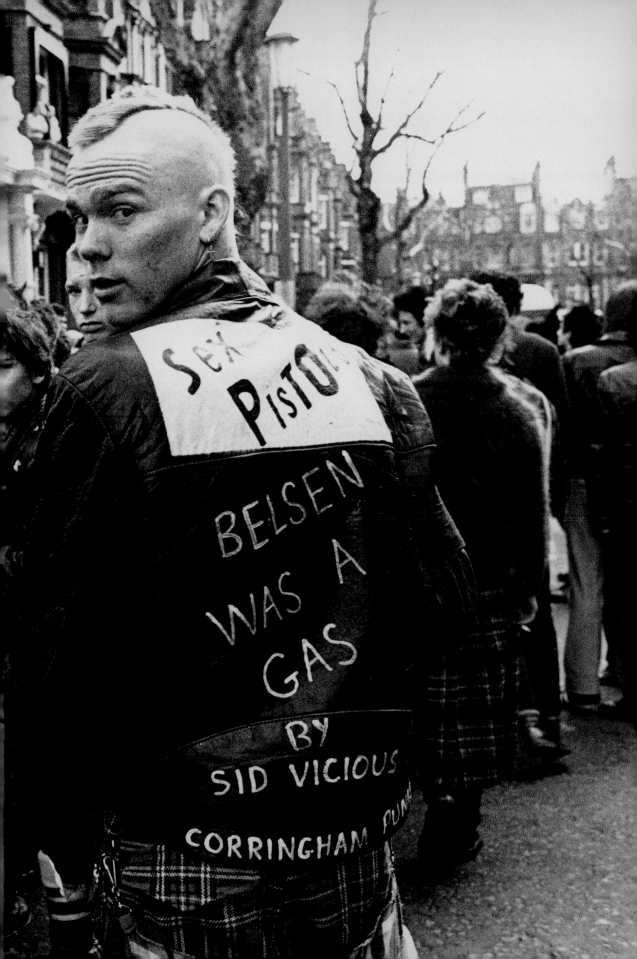

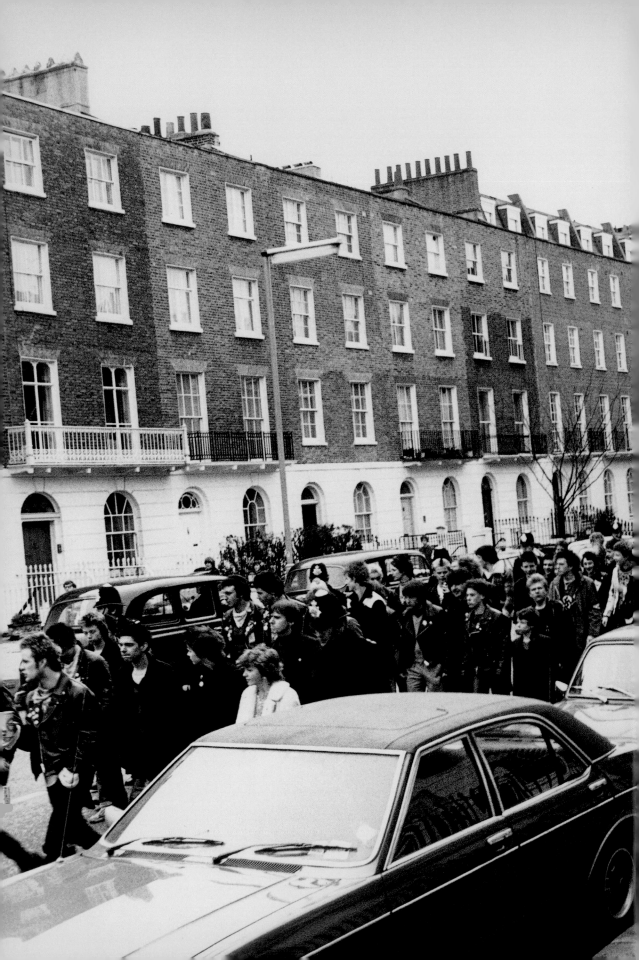

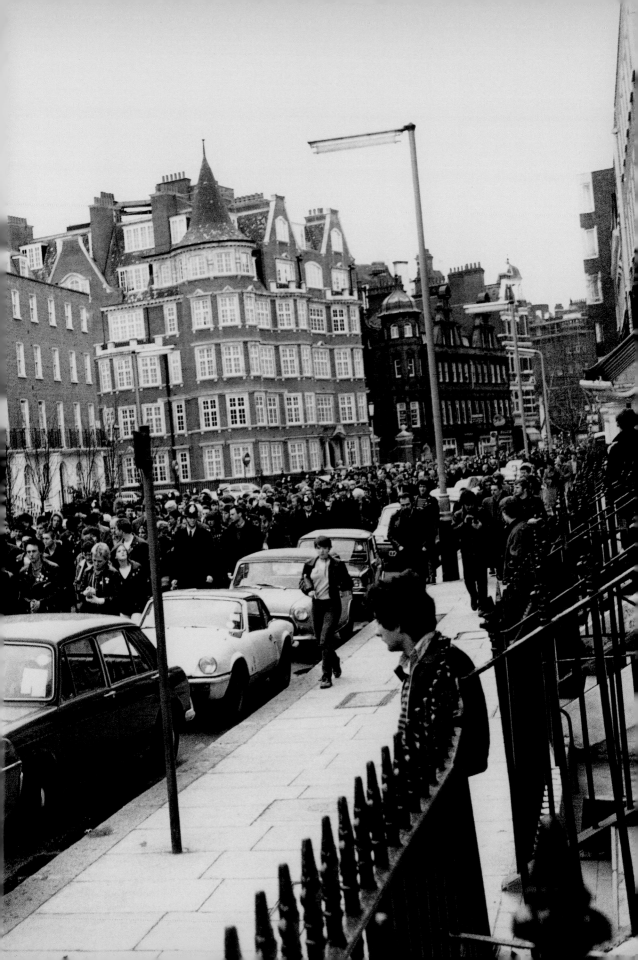

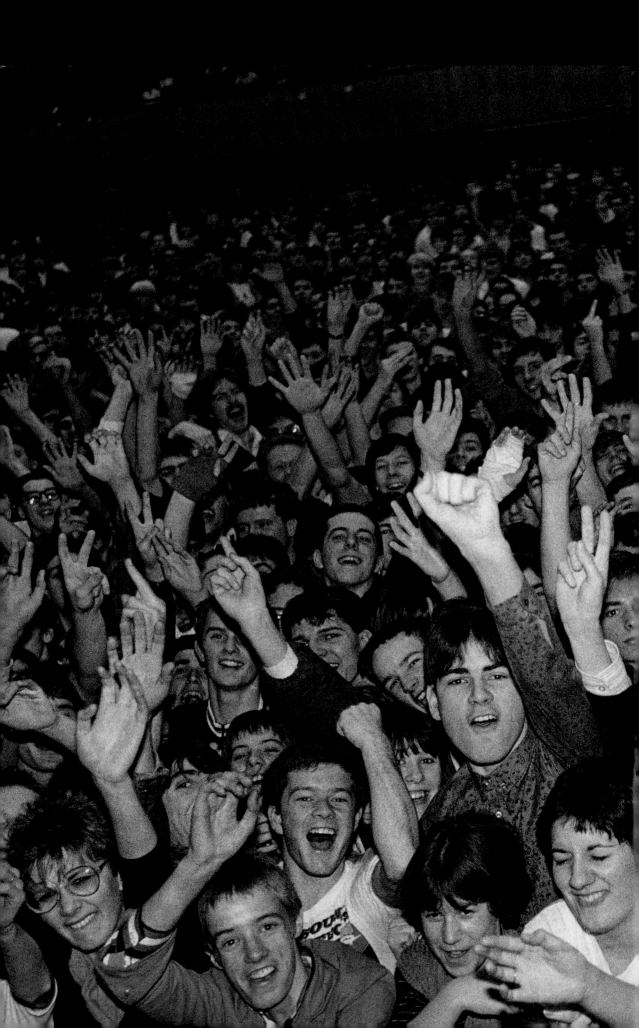

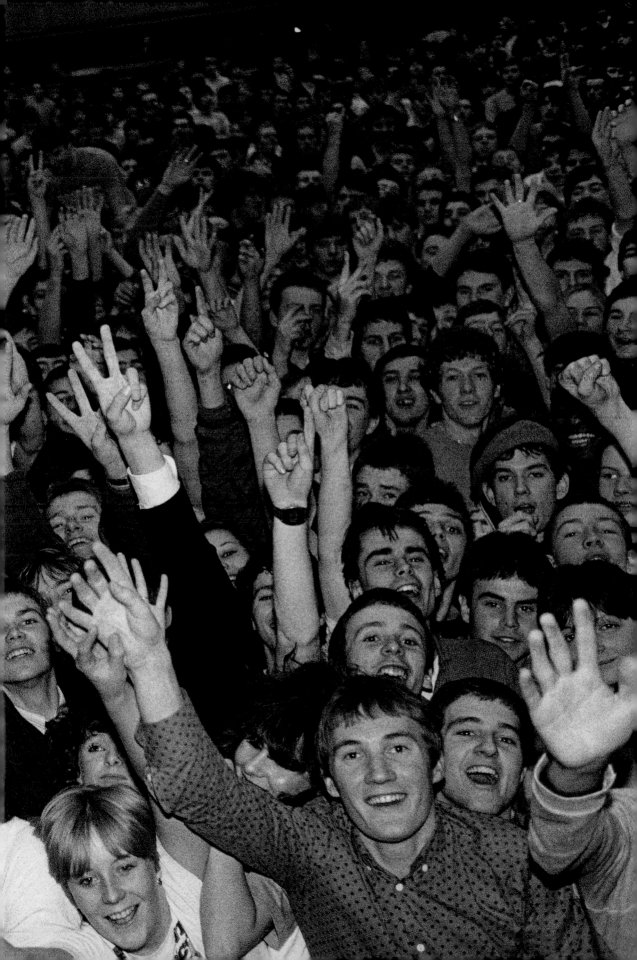

Joe Strummer, The Clash, Milan, 1981

Bad Manners, Camden Town, London, 1981

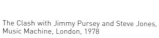

The Clash with Jimmy Pursey and Steve Jones,
Music Machine, London, 1978

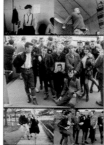

BP Fallon, Son of Stiff tour, Dublin, 1980

The Bureau, Coventry, 1980

Special Brew, Coventry, 1980

Doug Trendle, Bad Manners, Loch Lomond festival,
Scotland, 1981

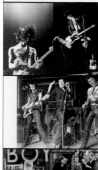

The Ramones, Hammersmith Odeon, London, 1980

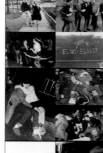

Teds, London, 1979

The Sex Pistols, London, 1977
Beckman/Moss

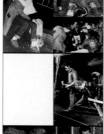

Phil (The Polecats) and friends, Caister, 1980

Rock 'n' roll dancers, Caister, 1980

Teddy boys, London, 1980

"Teds Rule" graffiti, London, 1980

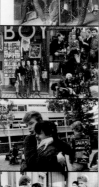

Boy, King's Road, London, 1979

Record shoppers, East End, London, 1979

Punks, World's End, London, 1978

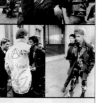

Rockabilly kiss, London, 1980

"The rumble," Caister, 1980

Weekend dance, Caister, 1980

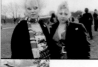

Punks, World's End, London, 1978

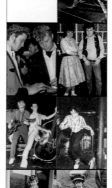

Tenpole Tudor, Son of Stiff tour, Dublin, 1980

Punk, West End, London, 1979

Punks, Coventry, 1979

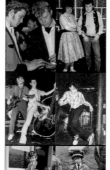

Teddy boys, Caister, 1980

Teddy couple, Caister, 1980

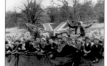

Punk girls, Hyde Park, London, 1979

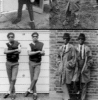

Smutty Smiff and Dibbs, The Rockats, London, 1981

Levi, The Rockats, London, 1981

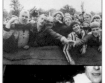

Skinhead, Coventry, 1980

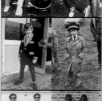

Teddy kid, Caister, 1980

Mod kid, Scotland, 1980

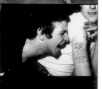

Skinheads with flag, Loch Lomond festival,
Scotland, 1981

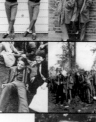

Rude boys, Chuka and Dubem, London, 1981

Mod twins, Chuka and Dubem, London, 1979

Fans, Loch Lomond festival, Scotland, 1981

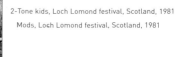

2-Tone kids, Loch Lomond festival, Scotland, 1981

Mods, Loch Lomond festival, Scotland, 1981

The Cockney Rejects, London, 1980

Mod girl, Streatham, London, 1976

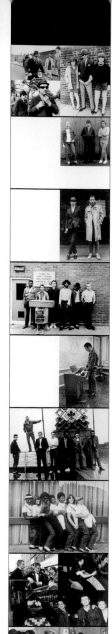
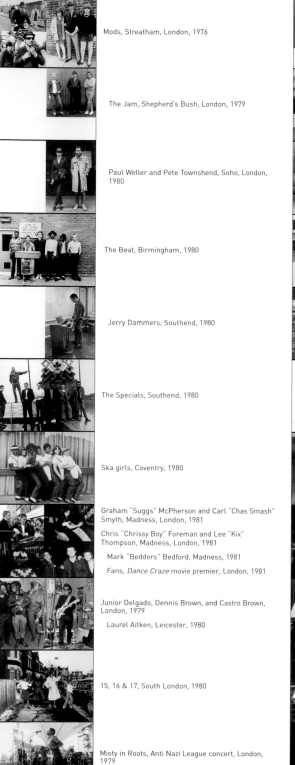
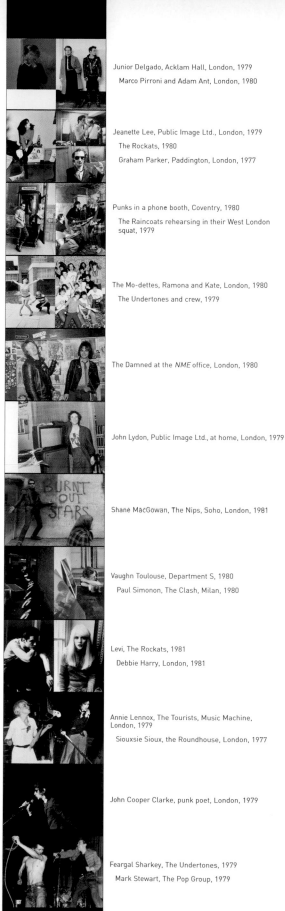

Mods, Streatham, London, 1976

The Jam, Shepherd's Bush, London, 1979

Paul Weller and Pete Townshend, Soho, London, 1980

The Beat, Birmingham, 1980

Jerry Dammers, Southend, 1980

The Specials, Southend, 1980

Ska girls, Coventry, 1980

Graham "Suggs" McPherson and Carl "Chas Smash" Smyth, Madness, London, 1981

Chris "Chrissy Boy" Foreman and Lee "Kix" Thompson, Madness, London, 1981

Mark "Bedders" Bedford, Madness, 1981

Fans, Dance Craze movie premier, London, 1981

Junior Delgado, Dennis Brown, and Castro Brown, London, 1979

Laurel Aitken, Leicester, 1980

15, 16 & 17, South London, 1980

Misty in Roots, Anti Nazi League concert, London, 1979

Ladbroke Grove sound system, London, 1979

Junior Delgado, Acklam Hall, London, 1979

Marco Pirroni and Adam Ant, London, 1980

Jeanette Lee, Public Image Ltd., London, 1979

The Rockats, 1980

Graham Parker, Paddington, London, 1977

Punks in a phone booth, Coventry, 1980

The Raincoats rehearsing in their West London squat, 1979

The Mo-dettes, Ramona and Kate, London, 1980

The Undertones and crew, 1979

The Damned at the NME office, London, 1980

John Lydon, Public Image Ltd., at home, London, 1979

Shane MacGowan, The Nips, Soho, London, 1981

Vaughn Toulouse, Department S, 1980

Paul Simonon, The Clash, Milan, 1980

Levi, The Rockats, 1981

Debbie Harry, London, 1981

Annie Lennox, The Tourists, Music Machine, London, 1979

Siouxsie Sioux, the Roundhouse, London, 1977

John Cooper Clarke, punk poet, London, 1979

Feargal Sharkey, The Undertones, 1979

Mark Stewart, The Pop Group, 1979

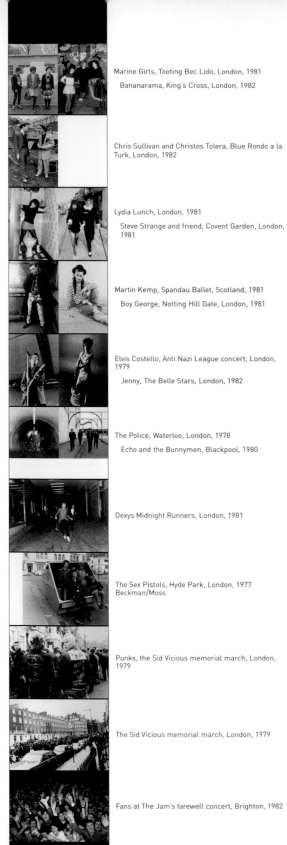

Marine Girls, Tooting Bec Lido, London, 1981
   Bananarama, King's Cross, London, 1982

Chris Sullivan and Christos Tolera, Blue Rondo a la Turk, London, 1982

Lydia Lunch, London, 1981
   Steve Strange and friend, Covent Garden, London, 1981

Martin Kemp, Spandau Ballet, Scotland, 1981
   Boy George, Notting Hill Gate, London, 1981

Elvis Costello, Anti Nazi League concert, London, 1979
   Jenny, The Belle Stars, London, 1982

The Police, Waterloo, London, 1978
   Echo and the Bunnymen, Blackpool, 1980

Dexys Midnight Runners, London, 1981

The Sex Pistols, Hyde Park, London, 1977
Beckman/Moss

Punks, the Sid Vicious memorial march, London, 1979

The Sid Vicious memorial march, London, 1979

Fans at The Jam's farewell concert, Brighton, 1982

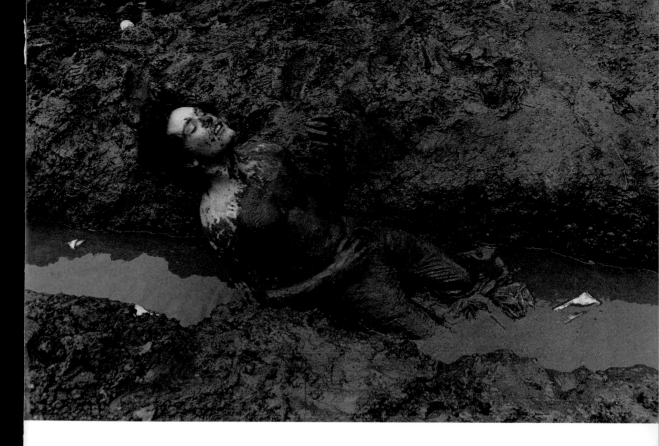

## Acknowledgements

Big thanks to everyone who helped me with this book.
Special thanks to Marissa Ferrarin for making it all happen. Marsel
for his love and support. The fabulous powerHouse crew for believing
in my photos and producing this book. My two best writer friends
from back in those days, Vivien Goldman and Paolo Hewitt, for
capturing the times so vividly. Paul Smith, Barney Hoskins, and
Rock's Backpages, Chris Salewicz, Sarah Marusek, David Corio,
Jill Furmanovsky, Julie Grahame, & Jon Espinosa.

page 54, quotes from *Soul Stylists* (Mainstream Publishing, 2000),
Paolo Hewitt

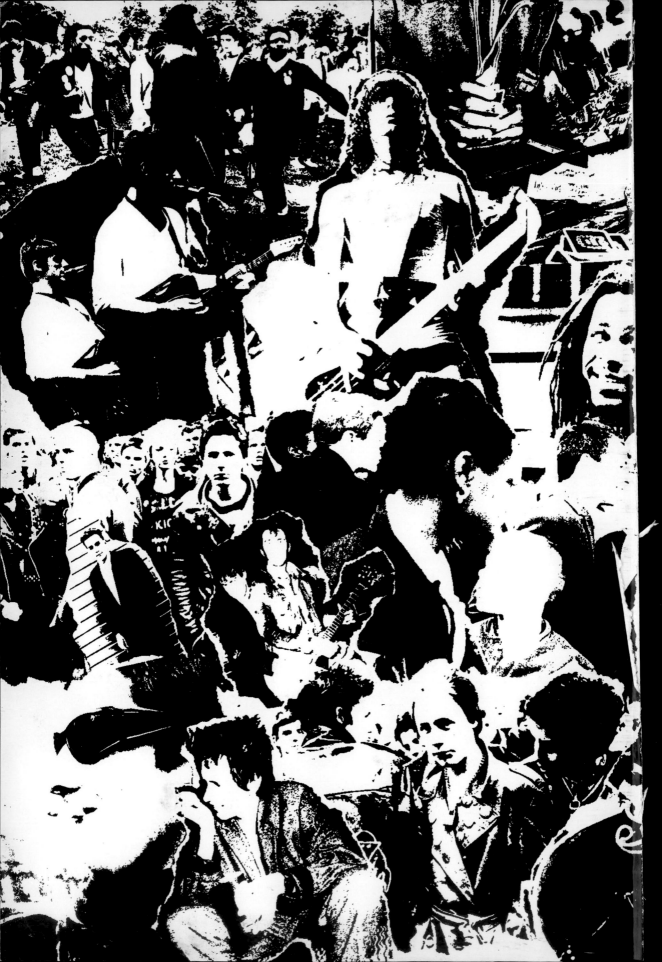